WITHDRAWN

The Art of the Russian North

Anne Odom

Abbott Gleason

William C. Brumfield

Alison Hilton

Hillwood *Museum & Gardens*

Washington, D.C.

N 6995. N59 A 78 2001

© 2001 Hillwood Museum and Gardens, Washington, D.C. All rights reserved.

Published by Hillwood Museum and Gardens to document the seminar *The Art of the Russian North* held at Hillwood in the fall of 1997.

Editor: Nancy Eickel
Designer: Polly Franchine, PrimaryDesign
Printer: Weadon Printing and Communications

Cover and title page: Bowl with signs of the zodiac on the back. Solvychegodsk. Late 17th century. Silver gift, enamel. Hillwood Museum and Gardens, Washington, D.C.

Library of Congress Cataloging-in-Publication Data
The art of the Russian North / Anne Odom . . . [et al.].
 p. cm.
 Proceedings of a seminar held at Hillwood in the fall of 1997.
 Includes bibliographical references and index.
 ISBN 1-931485-00-3
 1. Art, Russian—Russia, Northern—Congresses. I. Odom, Anne, 1935. II. Hillwood Museum and Gardens.

N6995.N59 A78 2001
700' 947'1—dc21 2001024060

Acknowledgments
I would like to thank several people, in addition to the authors themselves, for their assistance in making this project happen. Both Karen Kettering and Wendy Salmond read the whole manuscript and made comments. They were especially helpful to me in writing the introduction. Kristen Regina and Karen Kettering secured the permissions, for which I am most grateful. I thank Frederick J. Fisher, director of Hillwood Museum and Gardens, for his support in this endeavor.

Anne Odom
Deputy Director for Collections and Chief Curator,
Hillwood Museum and Gardens

Contents

Preface

We are pleased to present this new publication, the result of a seminar held at Hillwood Museum and Gardens in 1997 on the art of the Russian North. The seminar and this resulting volume represent a nascent effort by the museum to increase its scholarly pursuits. In recent years we have expanded our vision to widen the scope of academic activities to better support Hillwood's magnificent collection of Russian and French decorative arts.

I am most appreciative of Anne Odom, Hillwood's Chief Curator and Deputy Director for Collections, for orchestrating this fascinating seminar and assembling such a noted group of scholars, and for her untiring tenacity in the production of this publication. Further, I must thank her fellow panelists, Abbott Gleason, William C. Brumfield, and Alison Hilton, for their brilliant presentations. We are so pleased that they have agreed to allow us to make this information available to the field. Finally, I want to thank the museum's Board of Trustees for supporting this new scholarly initiative.

FREDERICK J. FISHER
Executive Director

Introduction
The Art of the Russian North

ANNE ODOM

This collection of essays is the fruit of an afternoon seminar held in the fall of 1997 at Hillwood Museum and Gardens in Washington, D.C. The seminar's purpose was to bring together people who had studied the art of the Russian North (*Russkii sever*), whether it be architecture, folk art, or the decorative arts. This seemed an unusual opportunity to elaborate upon a subject we thought particularly rich but too little explored in Russian cultural literature, not to mention works in English. As preparatory discussions proceeded, it became clear that our topics were also leading us into a discussion of the various meanings of "North" in Russia.

Initially, the North was a frontier to be conquered. (For purposes of this book, the Russian North is that region north of the Volga River and south of the White Sea. The Ural Mountains form the eastern border, and Finland, the border on the West. The area includes the pre-Revolutionary provinces of Vologda, Arkhangelsk, and Olonets.) As far back as the twelfth century much of the territory north of Iaroslavl had belonged to Novgorod. In the thirteenth and fourteenth centuries, Muscovite princes and the Orthodox Church established outposts along the rivers in Vologda Province as they asserted their power. From the fourteenth to the sixteenth century, monasteries also colonized the area as monks sought out the solitude of the wilderness for prayer and contemplation.

The cities of Ustiug and Vologda each occupied strategic positions on the river approaches to the forests that were so rich in furs, salt, wax, and hemp. The struggle between Moscow and Novgorod for hegemony over this area ceased when Ivan III crushed Novgorod in 1478. In 1553 Ivan IV (the Terrible) opened trade with England and later Holland via the White Sea and the Northern Dvina, at the confluence of which the port city of Arkhangelsk grew. This trade ensured an even greater stake on the part of Moscow in the cities along the Dvina, Sukhona, and Vologda Rivers.

Abbott Gleason, in his introductory essay, explores the role that ideas of North have played throughout the course of Russian history. He defines the North as "not Moscow," a place of escape and freedom, where peasants and religious ascetics and, after the Schism in 1667, the Old Believers could practice their religious beliefs without fear of persecution. Thus hermits and schismatics co-existed in this desolate

region with the merchants, bureaucrats, and artisans who populated the cities along the river route from Moscow to Arkhangelsk. Following the opening of trade with England, the cities of Iaroslavl, Vologda, Velikii Ustiug, and Arkhangelsk began to flourish. For these people, North could be equated with West, as the trade route became a conduit for new ideas and money.

Certainly the most famous of the merchant dynasties that grew out of the region was the Stroganov family. The family supported workshops in icon painting and textile embroidery at its seat in Solvychegodsk, and it presented gifts to churches as far removed as Nizhnii Novgorod on the Volga River. These northern cities were lively trading centers in the seventeenth century, rivaled only by Moscow. The north-south trade route declined after the founding of St. Petersburg, but it remained vital throughout the eighteenth century. Facing east, Velikii Ustiug was still the hub not only of the Siberian fur trade but also the center of trade with China. Trading caravans began making their way to China following the Treaty of Nerchinsk in 1689, which established relations between Russia and China. With the founding in 1727 of a permanent trading post in Kiakhta on the Chinese border south of Irkutsk, the number of caravans bringing Chinese valuables such as gold, silver, precious stones, silk, and tea into Russia increased. Velikii Ustiug was the entrepôt for this trade into western Russia. As a result, it and the cities to the south retained considerable economic importance even after the founding of St. Petersburg in 1703.

The splendid baroque churches, so beautifully photographed by William Brumfield, and the enameled and nielloed silver wares described in my essay are a testament to the artistic patronage of the Orthodox Church as well as of the local merchants and the creativity of the local artisans. As the North gradually became a backwater in the nineteenth century, these architectural and artistic artifacts were a reminder of the cultural life that had once flourished there and was still alive and well as late as the nineteenth century. Baron August von Haxthausen, traveling through Vologda Province in 1843, noted that "the desire for intellectual cultivation appears stronger here than in other districts. . . . The peasants frequently give their sons during the winter to the pope [priest] to be educated"[1] Among the Old Believers especially, reading and writing were not uncommon.

This area that had once enjoyed regular contact with the West had, by the late nineteenth century, become the destination of artists who were looking for a source of genuine Russian artistic inspiration, for the simplicity and tradition they believed was "authentically Russian." This paradox can perhaps be explained by the fact that

1. Franz August Maria von Haxthausen, *The Russian Empire* (New York: Arno Press, 1970), p. 196.

the western layer on the North was sufficiently in the past, was limited to the major towns along the rivers, and was so different from the growing industrialization of Moscow and St. Petersburg that it was no longer remarkable. Some artists, such as Mikhail Nesterov and Isaac Levitan, depicted the solitude and closeness to nature and may have been attracted by the North's reputation as a refuge. Others, among them Vasilii Kandinskii, became fascinated with the mix of pagan and Christian elements found in the art produced there. These artists viewed the North from the outside. What we experience in their paintings is their emotional response to this landscape.

Folk art may have initially thrived in this region precisely because of the active markets where peasant craftsmen could sell their wares at the annual summer fairs. As Alison Hilton points out, folk art profited from a close relationship with the market-place. The decorative traditions she so well describes persisted into the nineteenth century. Some of the motifs are found both in luxury wares and in folk art. The *sirin*, for example, appears on enameled wares intended for wealthy merchants and on wooden painted boxes and distaffs made for peasant women.

In the 1920s and 1930s, "North" took on new and equally important meanings. Both Abbott Gleason and Alison Hilton address this twentieth-century North briefly. What had been a haven for schismatics in the past was transformed into a hell for the prisoners that Lenin and Stalin sent off to serve their terms in these forbidding forests. "Solovki," the colloquial term for the prison in the Solovetskii Monastery, was among the first established by Feliks Dzerzhinskii for Lenin. Stalin would later populate Vorkuta, in the northern Urals, with tens of thousands of prisoners who were forced to build, under heavy snows, their own shelter from the vast forests. Others perished building the White Sea Canal, a futile project that was to link the Baltic with the White Sea. As a Stalinist achievement, this project found artistic expression in Aleksandr Rodchenko's photographs.

As these exploratory essays reveal, the art of the Russian North is a subject whose surface merely has been scratched. Ideally we would have included an essay on the Stroganov icon and textile workshops, which were a major contributor to the art of the North. The role of Old Believers in the arts of icon painting, manuscript decoration, and metalwork needs to be further explored. Despite these omissions, we have decided to publish these papers to encourage others to pursue an area of rich artistic production and inspiration.

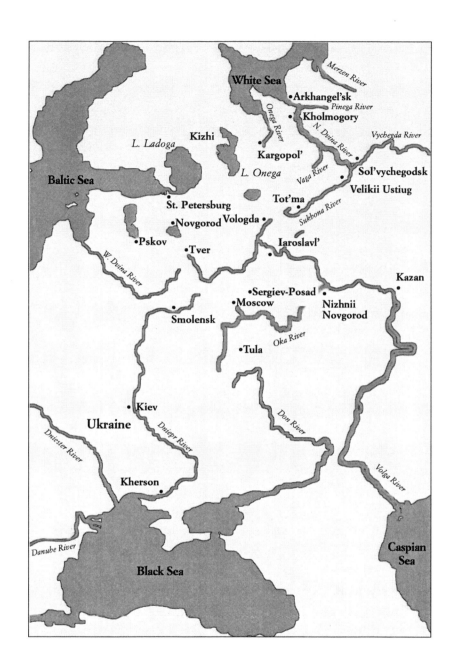

This map is based on that in *Russian Folk Art*, courtesy Alison Hilton and Indiana University Press

Meanings of North in Russian Culture

ABBOTT GLEASON

The notion of the art of the Russian North sounds much more straightforward than it is, for "North" has many meanings in Russian culture, many nuances, many contexts, and some profound ironies. In addition, meanings change, fragment, and recombine over time. It is my intention to explore some of those meanings and their changes and recombinations over several centuries. All this being as complex as it is, it is perhaps not absurd to remind ourselves initially that North is a point on the compass. While this is obvious, we should never lose sight of this basic datum, for it is connected to all the other meanings, however tangentially.

Only slightly less obvious is that some of the themes that we will explore do not begin or end at national boundaries. A great deal of the artistic production of northern Europe *as a whole,* for instance, is dominated by woods and forests, and music as much as painting, and no doubt the two are connected. However difficult this is to express in precise terms, the music of Edvard Grieg and Jan Sibelius is part of the same general Northern cultural space as are the paintings of the Russian artist Ivan Shishkin. Again thinking of Europe as a whole, it is rare that northernness as a cultural idea can totally escape from the spell of Norse mythology: the eddas and sagas, and the Viking experience.[1] Although connections between Russian cultural northernness and Scandinavia are complex, the Finnish element in the culture of Great Russia has long been noted by scholars and folklorists as well as by visual artists. Great Russians have a strong admixture of Finnish blood.

The romance of northernness has a number of variations in the United States as well as in Europe. Celebrated examples within English language culture include William Morris' lifelong obsession with Norse and Icelandic literature, not to speak of the well known and very northerly literary friendship between J.R.R. Tolkien and C.S. Lewis.

Turning specifically to the Russian historical context, what are some of the various meanings of North? When and where do we find them? We might begin by noting that in the Muscovite period, "North" was likely to mean "not Moscow" in both simple and complex ways. North of Moscow were the hermits in the woods, the remarkable Orthodox religious ascetics. The solitude and asceticism of these people

1. One sees this in numerous visual representations by Russian painters of Viking ships on Russian rivers. The work of Vasilii Kandinskii, among many others, provides several examples. Nicholas Roerich's sense of Russian history also had a strong Northern (and Viking) component. See N.K. Rerich, *Glaz dobryi* (Moscow: Khudozhestvennaia literatura, 1991), pp. 15–156.

brought them into conflict with the official church-state alliance in Moscow, first implicitly, then explicitly, at the turn of the sixteenth century.

In the sixteenth and seventeenth centuries, North was also a direction that fugitives took, usually peasants who were fleeing economic and/or religious oppression, particularly following the schism in the Russian Church. The further one got from Moscow, the worse the roads, the denser the forests, the more difficult the task of the pursuer. In that context, North came to stand for what was traditional, old, and therefore authentic, but also for what was free and untrammeled, imperilled, and in flight. Those things were being driven toward the periphery by the increasing centralization of the Muscovite autocracy, and North was a direction one went to oppose the state and what it was doing, actively or more usually passively. More concretely, North was where many Old Believer settlements were located, while Orthodoxy dominated the center. The far North was also among the few places in Muscovy where the land had not been given away by the tsar to one of his servants. Therefore, the peasants who lived on that land were not serfs.

It should be stressed, of course, that serfs fled south and west as well as north, to the Don and Volga, as well as into the woods and toward the shores of the White Sea. Flight from the center was by no means exclusively a "Northern" phenomenon. And Old Believers could take refuge "underground" in the very center of the Russian realm.

The ancient city of Novgorod and its vast, ice-bound territories stretching up to the White Sea were also the North in Russian history and were connected to notions of otherness from Moscow, even before the city was defeated militarily and annexed by Moscow in the fifteenth century. Novgorod's culture was more commercial and less politically monocratic than that of Moscow, and it was at least somewhat more cosmopolitan. After the eclipse of Novgorod, the decline of the Hanseatic League, and before Peter the Great founded St. Petersburg, trade routes to the West ran via northern towns, including Vologda, Velikii Ustiug, and above all Arkhangelsk. At this point North had some sense of Europe and in a rudimentary way, commerce and even cosmopolitanism, as the wealth and culture of those towns were largely mercantile in origin.

Novgorod icons were more modeled and more highly colored than those made in Moscow at roughly the same time (fig. 1). Scholars who have studied the subject in depth assure us that the influence of Novgorod icons can be perceived in northern towns long after Novgorod was overwhelmed by Moscow in the late fifteenth

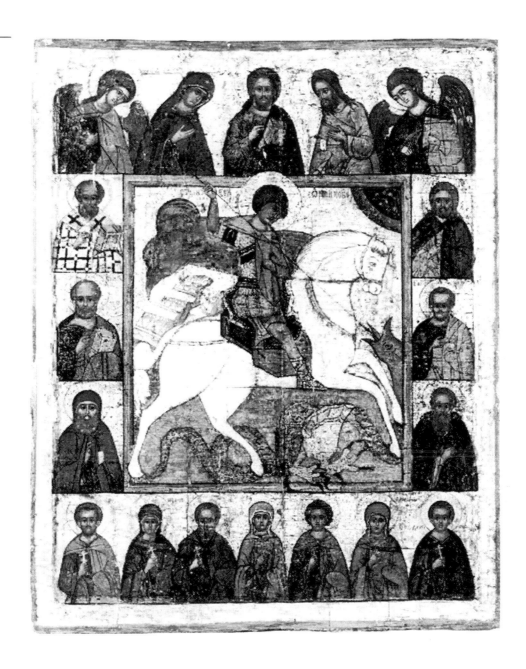

Figure 1
Icon of St. George.
Novgorod School.
16th century.
Tempera on wood.
Hillwood Museum
and Gardens,
Washington, D.C.

century. Northern architecture was more likely to be of wood than it was further south, where a stone church did not require such herculean efforts by the builder. Some of the most remarkable wooden architecture of the Russian North was located at Kizhi, including the Church of the Intercession and the Church of the Transfiguration (fig. 2). The generally anonymous craftsmen who constructed these buildings almost certainly had no *conscious* romance with the North, but in the nineteenth century the austerity, plainness, and purity of their work came to seem an essential aspect of Russia's northernness.

In the eighteenth and especially the nineteenth century, folklorists and ethnographers discovered that the most ancient East Slavic cultural artifacts were found not near Kiev, the cradle of East Slavic civilization, but north of Moscow and even St. Petersburg. These discoveries of folklore and epic song texts reinforced the earlier view that North meant purity and authenticity. The folk art of the northern Volga, the Kama, and the Northern Dvina also seems to have been particularly rich and varied.[2]

The Western orientation associated first with Novgorod was revived in the historical development of St. Petersburg, Peter the Great's famous "window on the West." Here is a bit of a confusion: prior to the nineteenth century, North could also mean West, or at least suggest it. The idea of North thus has—or had—simultaneous intimations of authenticity, venerability, and tradition on the one hand and cosmopolitanism on the other. The primal notion of Russian-style freedom (so much more anarchic than the Anglo-Saxon "liberty under law") is also a key meaning. These various cultural currents by no means pull in the same direction, and in fact they normally have been at odds with each other over the span of modern Russian history.

Generally speaking, the association of North with cosmopolitanism and Western commerce was lost over time, after the fall of Novgorod in the fifteenth century, but only slowly. The northern trade routes provided the economic backbone for a variety of strong local cultures, partly independent of Moscow and Novgorod, yet showing the influence of both. After icon painting began its steady decline in the seventeenth century, its vitality remained longer in northern cities such as Vologda, Iaroslavl, and Kostroma, even while the painting there took on certain Western features, some derived from the popular prints called *lubki*. Many of these icons and frescoes are a bit primitive, but their charm is equaled only by the sincerity and conviction they convey.[3] And of course the last great icon-painting school, that of the so-called Stroganov icons, can properly be called a Northern school, since it originated

2. Alison Hilton, "Folk Tradition and Individuality in Northern Russian Art," paper delivered to the AAASS, 1988.

3. Charming examples of both icons and frescoes with this folk quality may be found in G. Vzdornov, *Vologda* (Leningrad: Aurora, 1978). Alison Hilton has made clear the nexus between peasant folklore and the commerce of cities such as Arkhangelsk, Kholmogory, and Velikii Ustiug. See Hilton, "Folk Tradition," p. 16.

Figure 2
Church of the
Transfiguration. Kizhi.
1714.
Photograph by William
Brumfield.

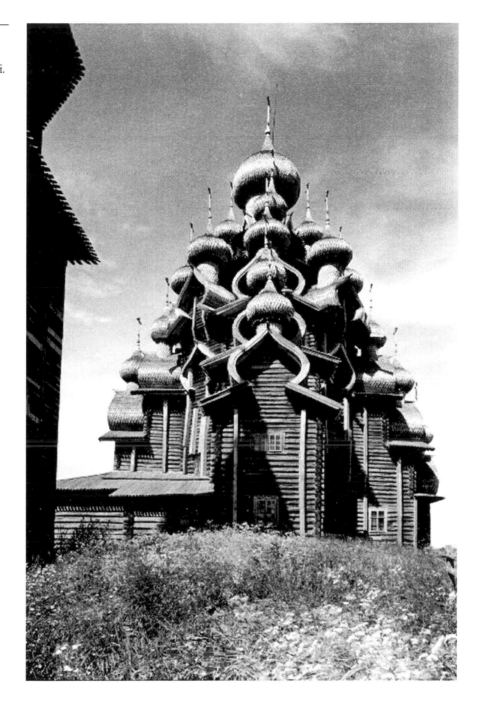

in Solvychegodsk, although its most famous painters relocated to the royal workshops in Moscow at the beginning of the seventeenth century.

When we look at the literary culture of the Petrine period—basically after 1700 until near the century's end—we find that Russia's northernness remains generally accepted, but there is no longer any clear definition of what Northern means. Part of this change occurred because the older identification of Russia with the East went dramatically out of style under Peter. For the Western-oriented elite, the East was now barbarous, slothful, and stagnant. Northern cold was activating, to say no more. In the official discourses of the Petrine and Catherinian period, "North" reacquired some of its older sense of cosmopolitanism and closeness to Europe, while it took on a more general identification with Russia in its current phase. But as yet, Russia's "northernness" is general and unconnected with anything visually concrete.

In some cases during the Petrine period and afterwards, North also refers to Russia's paradoxical "youth" after Peter's break with the Muscovite past. In other cases, North might suggest the obstacles that Peter the Great and Catherine the Great had to overcome in their ambitious project to turn Russia into a garden, both metaphorically and, especially in Catherine's case, actually.

> The forests, where only cold reigned,
> Where fear and horror lived,
> Have grown heavy with fruits,
> Have turned into a joyful garden.[4]

Taken from an anonymous poem, "Ode to the Planter of the Grapevine in the North," this suggests the somewhat jarringly mechanical application of European pastoral imagery to eighteenth-century Russia.

By the end of the eighteenth century, theories about the importance of climate for *national character*—itself only recently discovered—had become more significant, due in part to the profound influence of Montesquieu in Russia. Climate and physical circumstances were crucial to what Montesquieu enduringly called "the spirit of the laws." Subsequent to Montesquieu's time, the notion of North began to take on a new and more definite content, one suggesting not only Russian hardihood and simplicity but also dreaminess and romantic yearning.[5]

The ersatz Celtic epic "Ossian" also did an enormous amount to popularize ideas of Northern austerity, reflectiveness, and profundity, not merely in Russia, of course, but all across Europe. The poet Gavriil Derzhavin's sense of himself as profoundly a Northerner was vitally affected by the Ossianic tradition, and Catherine the

4. "Ode to the Planter of the Grapevine in the North," quoted in Otto Boele, *The North in Russian Literature* (Amsterdam: Rodopi, 1996), p. 29.

5. Ibid., pp. 36–40.

Great was for him the "Northern Minerva." It is worth noting that many Russian writers did not distinguish between Celtic and Scandinavian notions of northernness. The connection with Scandinavia can still be clearly seen today in northern Scotland, especially in the Orkneys. The Ossianic tradition had a powerful impact on almost all Nordic intellectuals, helping them to move Norse mythology out of the shadow of the Greek and Roman tradition. Russian poets such as Konstantin Batiushkov applied Ossianic imagery to neighboring Finland before applying it directly to Russia.[6]

Initially, the growing romantic appeal of Northern themes and images in Russia's nineteenth-century search for national identity was depicted largely in literature. Some interesting cartoons by the painter and caricaturist Aleksei Venetsianov depicting the defeat of Napoleon by the Russian winter, however, suggest that by the second decade of the nineteenth century Russians were beginning to link romantic ideas of northern toughness, profundity, and reflectiveness with the idea that they were the most northern of all Europeans.[7] "Born into the wide world under a cold northern star," wrote the nationalist S.A. Shirinsky-Shikhmatov, "fostered from youthful years by stern, grey winter, we despise foreign luxury; and loving our own fatherland more than ourselves, seeing in it a promised land flowing with milk and honey, for all the delights of southern nature we would not exchange our snows and the ice of our fatherland."[8] The poetry of Aleksandr Pushkin ("Winter Morning" and the beginning of Book Five of "Onegin") and Piotr Viazemskii ("First Snow") provides numerous examples of similar associations, and we begin for the first time to have some actual sense of what Russia's northernness actually looks like.

In the course of the nineteenth century, the meanings of North for Russia continued to develop. Russia's first important nationalist school, the Slavophiles, associated Russia again with the idea of East. Russians were the product not of the Western church, but the Eastern. Their disciples, however, continued to connect Russian national character with the North, recycling a number of earlier themes into an emotional notion of historical authenticity, connected with northern purity, austerity, and simplicity. These ideas found a growing resonance with visual artists.[9]

Among the best-known painters of the North was Ivan Shishkin from Yelabuga on the lower Kama River (fig. 3). Shishkin spent some time abroad in the early 1860s, but he suffered from constant homesickness for Russia. Shishkin, wrote one of his more sympathetic critics,

is a true son of the wilds of the northern forest, in love with this impenetrable, severe wilderness, with its pines and firs, stretching to the sky, with the mute, untamed hinter-

6. See Christopher Ely, "This Meager Nature," a revised version of his 1997 Brown University doctoral dissertation, chap. 3, esp. pp. 123–24.

7. See the dedication to "Alexandre du Nord," in C.-N. Ledoux, *L'Architecture considerée sous le rapport* . . . (Paris, 1804).

8. S.A. Shirinsky-Shikhmatov, "The Return to his Native Land of my Beloved Brother Paul . . .," quoted in Ely, "This Meager Nature," pp. 115–16.

9. This lengthy process is the subject of Ely's brilliant "This Meager Nature" (unpublished manuscript).

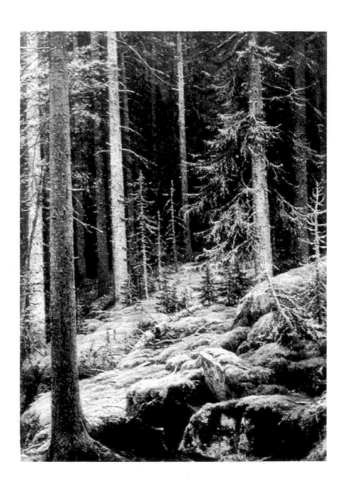

Figure 3
Ivan Shishkin
(1832–1898).
The Thicket. 1881.
Oil on canvas.
Tretiakov Gallery,
Moscow.

10. A.V. Prakhov, "Vystavka
v akademii khudozhestv
proizvedenii russkogo
iskusstva," *Pchela* 17 (1878),
quoted in Irina Shuvalova,
*Ivan Ivanovich Shishkin. Mir
khudozhnika: Perepiska,
dnevnik, sovremenniki o
Khudozhnike* (Leningrad:
Iskusstvo, 1978), p. 268. This
slightly defensive
homesickness for Russia in
the midst of the apparently
benign beauties of western
Europe was already a theme
in Russian poetry before
Shishkin's time. See Boele,
North, pp. 159–63, and Ely,
"This Meager Nature," pp.
297–301.

11. E.G. Kiseleva,
*Moskovskii khudozhestvennyi
kruzhok* (Leningrad:
Iskusstvo, 1979), quoted in
Ely, "This Meager Nature,"
p. 395, n. 77.

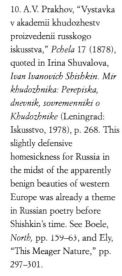

lands of the gigantic trees. . . . He's in love with the distinctive character of each tree, of each bush, of each blade of grass, and like a loving son he values each wrinkle on his mother's face.[10]

Note the characteristic reference to Russia as "mother."

The artists who gathered around Savva Mamontov at the artists' colony of Abramtsevo strongly associated the North with folk art and therefore with an authentic Russian tradition. They were attempting to discover and revive this tradition, both for its own sake and to inspire the "high art" of their contemporaries. Mamontov's correspondence yields repeated instances of various nineteenth-century artists rhapsodizing over, for example, "the northern Dvina, this enormous, beautiful river," or locating the "secret of Russian art" in the austere, unspectacular, humble landscape of the northern forests and rivers.[11]

Figure 4
Mikhail Nesterov
(1862–1942).
The Taking of the Veil.
1897. Oil on canvas.
State Russian
Museum.

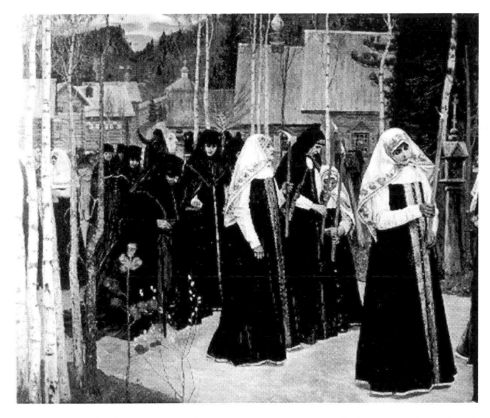

Between the late 1880s and the new century, many of the most talented and searching artists of the day interested themselves in northern Russia. Some, such as Konstantin Korovin, moved from beautiful idealizations of the North to grainier and more specific images. It is interesting, for example, to contrast his *Northern Idyll,* painted in 1886, with his very different *In the North,* painted a decade later after his trip to Murmansk with Valentin Serov.[12]

The visionary artist Mikhail Nesterov, a habitué of Abramtsevo, was among those who were most drawn to northern Russia. In working on the background to his famous religious canvas *The Taking of the Veil* (fig. 4), he wrote of the resurrected "Russian North, quiet and delicate," whose depiction could not fail to make his canvas "touching" to those in whom "tender feelings" still lived.[13] When he first visited the Solovetskii Monastery in 1901, in search of material for his epic canvas *Holy Rus,* he heard for himself the "quiet song of the North" that he felt was so crucial to Russian identity. It seemed to him that he had anticipated the monks he found there in his earlier *Hermit,* but he made many new paintings of their quiet everyday

12. On this trip (1894), see Sarabianov, *Russian Art* (New York: Harry Abrams, 1990), p. 213; D.Z. Kogan, "Korovin," in *Istoriia russkago iskusstva,* vol. X, pt. 1 (Moscow, 1968), pp. 325–28; and Alexander Kamensky, *Konstantin Korovin* (Leningrad: Aurora, 1988), pp. 4–5.

13. M.V. Nesterov, *Pis'ma* (Leningrad: Iskusstvo, 1988), p. 162.

rounds.[14] Most of the monks he often portrayed, as in *The Little Fox,* were implicitly or explicitly linked to the far North.[15]

One of the most famous voyagers to the North was the artist-illustrator Ivan Bilibin, who made three summer trips to Vologda, Olonets, and Arkhangelsk provinces in 1902, 1903, and 1904. He published an account of his travels in the journal *Mir iskusstva* in 1904, together with extensive drawings and photographs of churches, decorated peasant implements, and huts. His photographs and essay attracted a great deal of attention to the antiquities of the North, and he played an important role in drawing the attention of educated Russians to the remarkable churches at Kizhi.[16]

Vasilii Kandinskii also made an important trip to the North in 1889. He was not yet focused on painting; in fact, he was doing research on the Finnic Komi people, whom he and others referred to as Zyrians. He was, however, powerfully affected by the folk art and the architecture of the region, as is clearly evident in his subsequent art.[17] He was also greatly drawn to the Finnic and pagan dimensions of northern culture, particularly to symbols of Arctic shamanism. This again points up the complex interconnections between Finnic and East Slavic culture. He became a passionate devotee of the Kalevala, and the late art historian Peg Weiss has documented the duration and extent of those iconic elements in his work.[18]

Over the course of the nineteenth century, then, Russians learned to love the deep, tangled forests of the North, even those so northerly that broadleaved trees were rare. Perhaps that is why the birch tree became such an obvious symbol of Russianness, in music as well as in art. In a number of Mikhail Nesterov's pictures, perhaps most of all in *The Taking of the Veil,* there is an almost mystical connection between the human figures and the trees: slim, delicate, austere, spiritual, melancholy.

Speaking of the extraordinary number of birch-tree landscapes, this is what Fedor Dostoevskii wrote about a famous one that was going to Vienna in an exhibition of Russian landscape painting. The spectacular mountain scenery of the Caucasus, he imagined, would find favor with the Austrians. "However," he continued,

> I do believe that our Russian, preeminently national landscape, that is of the northern and central regions of our European Russia, will produce in Vienna no great impression. And yet, to us, this "weary nature," whose whole character resides, so to speak, in its lack of character, is dear and charming. Take, for instance, those two little birches in Mr. Kuindzhi's landscape *A Scene in Valaam:* in the foreground, a marsh and swampy sedge; in the background—a forest; over it—not exactly a cloud, but mist, dampness—

14. Ibid., p. 194. See also A.A. Fedorov-Davydov, *Russkii peizazh kontsa XIX–nachala XX veka* (Moscow: Iskusstvo, 1974), pp. 99–100.

15. I. Nikonova, *Mikhail Vasilevich Nesterov* (Moscow: Izdatelstvo "Iskusstvo," 1962), p. 93.

16. Ivan Bilibin, "Narodnoe tvorchestvo russkago severa," *Mir iskusstva* 11, no. 4 (1904), pp. 303–18 (bound and paginated with vol. 12).

17. See Peg Weiss, *Kandinsky and Old Russia* (Princeton, N.J.: Princeton University Press, 1995), and Alison Hilton, *Russian Folk Art* (Bloomington: Indiana University Press, 1995), pp. 245–46.

18. Weiss, *Kandinsky.*

one is, as it were, penetrated by it; you almost feel it, and in the middle, between the forest and yourselves, two little white birches, bright, hard—the strongest point in the picture. Now what is there peculiar about this? What is characteristic about this?— And yet, how beautiful it is. . . . I may be mistaken, but this will not please the Germans as much.[19]

The identification of a humble, austere Russia with the North did not die immediately with the Revolution of 1917. In 1920 the late impressionist artist Igor Grabar was painting the Northern Dvina and along the White Sea, a region "which captivated him."[20] Of course, it was difficult to be explicit about Northern interests during the early, "heroic" period of socialist realism, but Northern painting certainly continued.

Explicit reference to the North in Russian literature made a triumphant return in the 1950s, with the so-called village prose writers. When Aleksandr Solzhenitsyn launched his audacious plea to the Soviet leaders in 1974 to abandon their empire of conquest, it was to the Russian North that he besought Russians to "come home."[21] For some village prose writers, such as Valentin Rasputin, ideas of North were overwhelmed by Siberia as the new locus of Russian authenticity, but for others, including Fedor Abramov, the North remained the key.[22]

In the rhapsodies of the late Dmitrii Likhachev, who in his old age was arguably the most famous living student of Russian culture at home or abroad, many of these themes come together. "In the Russian North," he writes,

there is a most amazing combination of the present and the past, of contemporaneity and history (and what history—Russian!—the most significant, the most tragic in the past and the most "philosophical"), of human beings and nature, of the aquarelle lyricism of water, of the earth, the sky, the mighty power of the stone, of the storms, the coldness of snow and of the air. . . . But the main thing, the reason why the North cannot fail to touch the heart of every Russian—is that it itself is the most Russian of all. It is not only Russian in its soul, it is also Russian because of the outstanding role it has played in Russian culture. It not only saved Russia in the most difficult times of Russian history: in the time of the Polish-Swedish intervention, in the times of the first patriotic war and the Great War. It also saved from oblivion Russian epic tales, old Russian customs, Russian wooden architecture, Russian musical culture, the great Russian lyrical element in word and song, Russian traditions of labor, those of peasants, artisans, sailors, fisherman. From that region came remarkable Russian pioneers and travelers, explorers of the Polar Circle, and steadfast warriors who have no equal.[23]

I want to end on a different note, one which is both paradoxical and profoundly sad. As my colleague Alison Hilton observes, considering the dominant meanings of purity and authenticity attached to the idea of North by Russians, it is deeply ironic

19. Fedor Dostoevskii, *The Diary of a Writer,* translated and annotated by Boris Brasol (Salt Lake City: Peregrine Smith Books, 1985), p. 76.

20. V.G. Azarkovich and N.V. Egorov, *Igor Grabar* (Leningrad: Aurora, 1974), pp. 14–15.

21. Aleksandr I. Solzhenitsyn, *Letter to the Soviet Leaders* (New York: Harper and Row, 1974), pp. 26–32 ("The Russian Northeast").

22. Fyodor Abramov, *Two Winters and Three Summers* (New York: Harcort Brace Javanovich, 1984; Russian original, *Dve zimy I tri leta*), published in *Novy Mir* in 1968. On the complex relationship between the North and Siberia, see Kathleen Parthé, "Village Prose Writers and the Question of Siberian Cultural Identity," in Stephen Kotkin and David Wolff, eds., *Rediscovering Russia in Asia: Siberia and the Russian Far East* (Armonk, N.Y.: M.E. Sharpe, 1985), pp. 108–17.

23. Dmitrii Likhachev, *Kniga bespokoistv,* pp. 289–91, quoted in Riasanovsky, "Dmitrii S. Likhachev and Russia: A Critical Appreciation," *Russian History* 23, nos. 1–4 (1996), pp. 146–47.

that the most terrible sufferings of political prisoners during the Soviet period took place in many of the very same settings celebrated by earlier generations and even contemporaries, such as Likhachev. Russia's forests, northern rivers, and icy coasts became locations where Russians and foreigners alike died by the millions, especially in the middle third of our terrible century, in labor camps. Russian history may be uniquely characterized, as many have suggested, by the close proximity of the holy and the unholy, the lofty and the obscene, the sublime and the horrific.

Patronage and Church Architecture in the Russian North:
The Wealth of Vologda Province

WILLIAM C. BRUMFIELD

Vologda Province, located some 400 kilometers northeast of Moscow, is one of the largest territories in European Russia. The province (or *oblast,* as such administrative regions are known in Russian) has always been sparsely populated, yet the Vologda territory during the late medieval period acquired enormous strategic importance for the Muscovite state. Although the earliest historical references to its settlements date as far back as the twelfth century, it was the rise of the Muscovite principality, beginning in the fourteenth century, that provided the structure within which the region's resources could be exploited.

A number of factors contributed to this process. With the establishment of a metropolitanate of the Orthodox Church in Moscow, the church began to play an essential role in the advancement of Moscow's position throughout the North. In particular, the founding of monasteries by clerics from Moscow's own monasteries provided not only places of spiritual refuge and retreat but also centers of Muscovite influence. Two of the most influential of these monastic institutions were the St. Kirill Belozerskii Monastery, near the entry of the Sheksna River into the White Lake (*Beloe ozero*), and the nearby Ferapontov Monastery, both of which had close connections to the Muscovite court.[1] By the very nature of the relations between church and state in medieval Moscow, these and other monastic institutions, such as the Savior-Prilutskii Monastery near Vologda, represented both ecclesiastical and secular power in the North, and the Muscovite court supported them accordingly, with grants of land and money as well as tax relief.

With the expansion of Moscow's influence and the establishment of stable, if rudimentary, institutions for governance within the Russian North, there appeared a third factor (after church and state) for the development of wealth in the area leading to the White Sea. For a few well-placed entrepreneurs—most notably the Stroganovs—who were capable of understanding and exploiting the natural resources (salt, fur pelts, forest products) of this harsh environment, the North provided great wealth. This economic factor was particularly important in the sixteenth and seventeenth centuries, when the river network of the Northern Dvina served as one of Muscovy's most important trading arteries, both to the West and to Siberia. Even after the founding

1. Funds provided by the National Council for Eurasian and East European Research (NCEEER), under the authority of a Title VIII grant from the U.S. Department of State, assisted in the preparation of this article for publication. Neither NCEEER nor the U.S. government is responsible for the views expressed within this text. On the architectural history of the St. Kirill and Ferapontov monasteries, see I.A. Kochetkov, O.V. Lelekova, and S.S. Podiapolskii, *Kirill-Belozerskii i Ferapontov monastyri: arkhitekturnye pamiatniki* (Moscow: Teza, 1994).

of St. Petersburg in 1703, this entrepreneurial impulse in the North remained strong throughout the eighteenth century, as northern merchants established trading companies whose reach extended as far as North America.

It should be emphasized that each of these three entities (state, church, and entrepreneur) depended on the other two to maintain their considerable privileges. Ultimately, it was this interdependence that created the great wealth of religious art and architecture in the North from the sixteenth through the eighteenth centuries. The support that churches and monasteries received not only from the state but also, more importantly, from private donors enabled the flourishing of crafts for both religious and secular purposes. In turn, the presence of groups of skilled craftsmen, supported by patrons such as the Stroganovs, had a ramifying influence on folk art as well as on high culture throughout the North.

The extent of this wealth is still evident in the city of Vologda, which became the cultural and political center of the North during the late medieval period. Its origins go back at least to the twelfth century, when the area was explored and colonized by merchants and settlers from Novgorod, located some 500 kilometers to the west of Vologda and one of the most important economic centers of medieval Russia. At the end of the fourteenth century, Moscow had its own representatives in the town. A century later, after a prolonged, complicated struggle, Vologda and its surrounding territory were taken into the Moscow principality. By the middle of the sixteenth century, Vologda had become the administrative center of northern Russia. It also served as the primary distribution point for rapidly increasing trade with England, and subsequently Holland, by way of Arkhangelsk and the Northern Dvina River.[2] During this period Ivan IV commissioned the city's first major cathedral, to be discussed below.

In the immediate area of Vologda, the earliest significant masonry structure is the Cathedral of the Savior at the Savior-Prilutskii Monastery. Established to the northwest of Vologda in 1371, the Savior-Prilutskii Monastery was supported by Moscow's grand prince Dmitrii Ivanovich (Donskoi) as one of the first bulwarks of Orthodox Moscow in the rich but difficult terrain surrounding Vologda.[3] The original buildings, including the main church, were made of logs. After its destruction by fire, the Cathedral of the Savior was rebuilt in brick (1537–42) with substantial support from Moscow, including a decree issued in 1541 by the young Ivan IV releasing the monastery from all taxes for a period of five years. Larger than the cathedrals at St. Kirill and Ferapontov monasteries, the Savior Cathedral is similar to other major

2. A study of the trade between Russia and Holland during this period is contained in M.I. Belov, "Rossiia i Gollandiia v poslednei chetverti XVII v.," in *Mezhdunarodnye sviazi Rossii v XVII–XVIII vv. (ekonomika, politika, kultura)*, (Moscow, 1966), pp. 58–83.

3. On the Spas-Prilutskii Monastery, see G. Bocharov and V. Vygolov, *Vologda. Kirillov. Ferapontovo. Belozersk* (Moscow: Iskusstvo, 1979), pp. 127–51; and Gerold Vzdornov, *Vologda* (Leningrad: Aurora, 1978), pp. 110–20. The second part of its name derives from the monastery's location near a bend (*luka*) in the Vologda River.

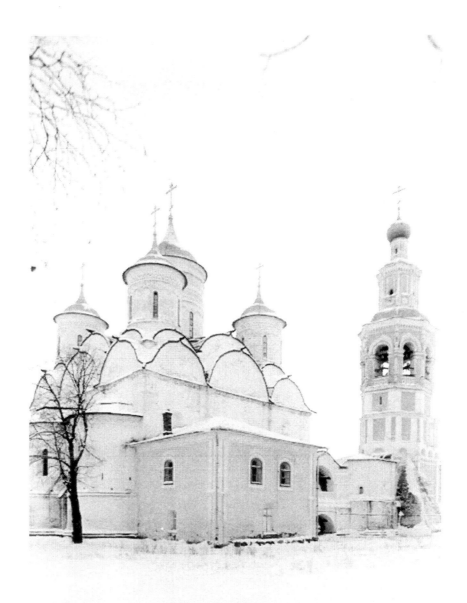

Figure 1
Cathedral of the
Savior (1537–42) and
bell tower (17th and
18th centuries).
Savior-Prilutskii
Monastery. Vologda.
Northeast view.
Photograph by William
Brumfield.

monastery churches whose design derived from the main Kremlin cathedrals. At the
same time, it displays distinctive elements that link it to its northern predecessors.

The cathedral walls support two rows of curved structural gables, or *zakomary,*
leading to a clearly spaced ensemble of five drums and cupolas (fig. 1). The upper

parts of the drums show ornamental brickwork in the Pskov style, which had been assimilated throughout Muscovy in the fifteenth century, although not in the Kremlin cathedrals. The main cupola, much larger than the flanking four, creates a strong vertical point to the pyramidal shape. The height of the structure is increased by a *podklet,* or socle, which contained a separate church for use primarily in the winter (a feature typical of Muscovite churches). The interior of the Savior Cathedral, whose whitewashed walls were never painted with frescoes, possesses an austere monumentality displayed in the ascent from the four piers to the corbelled vaults (reflected in the exterior *zakomary*) that support the cupola drums. The vaulting is reinforced with iron tie rods. A raised gallery attached to the north, west, and south facades leads on the southeast corner to a refectory and the Church of the Presentation (fig. 2), built in the late 1540s in a style similar to the refectory churches at St. Kirill and Ferapontov monasteries, with a roof of decorative *kokoshniki* ascending to a single cupola. The ensemble is completed by a bell tower that was rebuilt in the mid-seventeenth century.

The increasing power of Moscow in the late fifteenth and sixteenth centuries was reflected in the construction of large churches resembling the main cathedrals of the Moscow Kremlin, and Vologda would benefit from this process during the reign of Ivan IV (the Terrible). Like all northern towns of the medieval era, Vologda consisted almost entirely of log structures. Significant masonry work did not appear until 1565, when Ivan included the town in his private domain (*oprichnina*) and initiated construction of a fortress, or kremlin, apparently to serve as his northern residence. After the onset of a plague epidemic in 1571, Ivan left Vologda for Moscow. At this point, the enterprise was abandoned, and the walls were eventually dismantled.

Nonetheless, the most important monument of the Vologda citadel remained: the Cathedral of St. Sophia (fig. 3). Built from 1568 to 1570, the Sophia Cathedral was intended to serve as the seat of a bishopric after the expansion of the territory of the Vologda eparchy in 1571.[4] Indeed, the unusual dedication of the building, to St. Sophia (more precisely, to Divine Wisdom), can be interpreted as a direct challenge to the great eleventh-century Sophia Cathedral in Novgorod, by then completely subjugated to Moscow after a confrontation that had lasted over two centuries. Because of various political and ecclesiastical complications, however, the Vologda cathedral was not consecrated until 1588, following the death of Ivan the Terrible.

The St. Sophia Cathedral is an excellent example of mid-sixteenth-century church architecture based on Aristotle Fioravanti's Dormition Cathedral (1475–79) and the

4. An analysis of the history and architecture of the Vologda St. Sophia Cathedral is contained in Bocharov and Vygolov, *Vologda,* pp. 26–38; and G.K. Lukomskii, *Vologda v ee starine* (St. Petersburg: Sirius, 1914), pp. 59–72.

Figure 2
Refectory of the
Church of the
Presentation of the
Virgin. Savior-
Prilutskii Monastery.
Vologda. Late 1540s.
East facade.

Photograph by William
Brumfield.

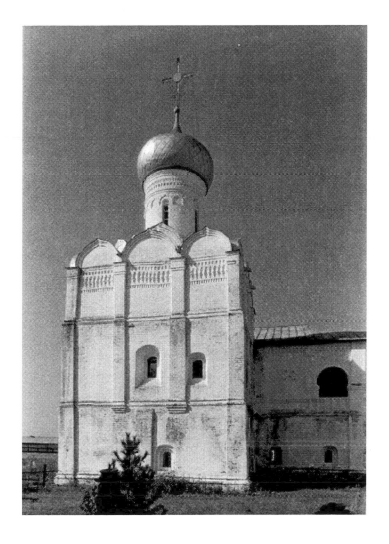

Cathedral of the Archangel Michael (1505–1508) by Aleviz Novyi, both in the
Moscow Kremlin. Like other major cathedrals of this type (the Dormition Cathedral
at Rostov, the Cathedral of the Smolensk Icon of the Virgin at Novodevichii Convent,
and the Dormition Cathedral at the Trinity-St. Sergius Monastery), their resemblance
to the Moscow Kremlin cathedrals reflects not only the remarkable tectonic logic cre-
ated by the Italians in their interpretation of Russian church architecture but also,
implicitly, the preeminence of Moscow as defender of the faith and of the Russian
lands.

Figure 3
Cathedral of St.
Sophia. Vologda.
1568–70. Southeast
view.
Photograph by William
Brumfield.

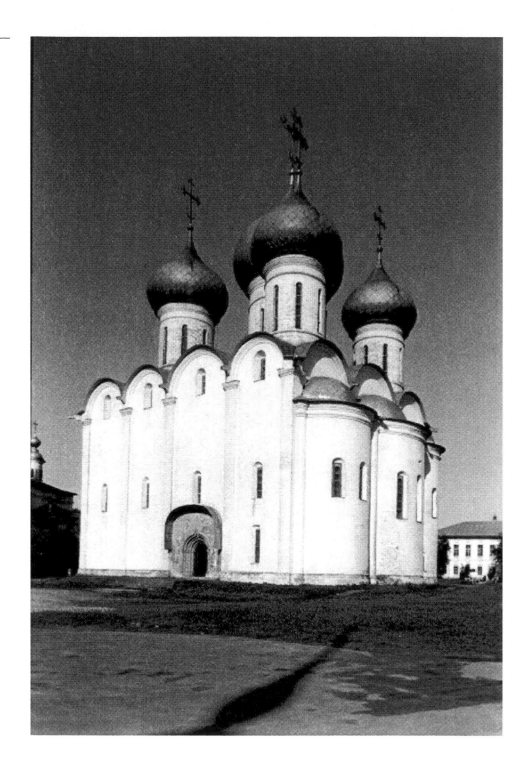

Figure 4
Cathedral of St. Sophia. Vologda. Interior. View southeast, with iconostasis (late 17th to early 18th centuries).
Photograph by William Brumfield.

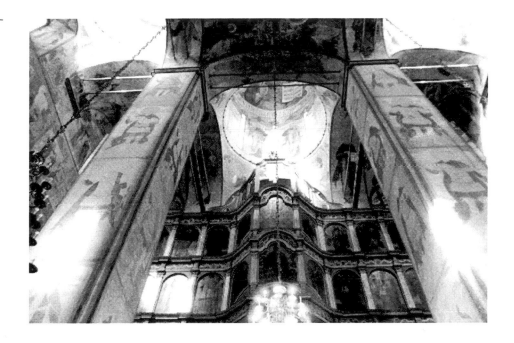

5. On Italian influence in late fifteenth and early sixteenth-century Muscovite architecture, see William Craft Brumfield, *A History of Russian Architecture* (Cambridge: Cambridge University Press, 1993), pp. 92–106.

Fortunately, the Cathedral of St. Sophia has been well preserved. Its whitewashed brick walls are outlined by pilaster strips that lead to a horizontal row of semicircular gables, or *zakomary,* which were restored to their original configuration after the Second World War. The onion domes, which provide a majestic crown to the structure, evolved to their present form as the result of modifications made to the building during the seventeenth century. (Their original form would presumably have been closer to the hemispherical shape still retained in the Dormition Cathedral of the Moscow Kremlin.) The elaborate iron crosses above the cupolas were added in 1687. The segmentation of the exterior corresponds to the interior bays and their vaulting, which follows a cross-inscribed plan with the five cupola drums shifted to the east. The interior is segmented by six great piers, with an iconostasis rising in front of the east piers (fig. 4). The influence of Fioravanti's Dormition Cathedral is pervasive and includes the absence of an interior gallery, thus admitting more light from the windows of the main walls, and the reinforcing of the vaulting with iron tie rods.[5] In 1686–88 the entire interior was painted with frescoes by a group of some thirty masters from Iaroslavl.

With the exception of the Sophia Cathedral, Vologda throughout the sixteenth and early seventeenth centuries remained a collection of log structures that was more than once devastated by fires. In addition to these natural disasters, the city was sacked in 1612 during the Time of Troubles. Nonetheless, Vologda's strategically important position assured its continued existence on a scale that impressed foreign merchants and emissaries, some of whom left drawings of its expanse of church towers and log houses. As the city recovered in the 1620s, the increasing wealth of its merchants permitted the more frequent use of masonry construction as a partial antidote to the ever-present danger of fire.[6] Some of Vologda's seventeenth-century churches will be mentioned below.

In the final two decades of Ivan the Terrible's reign, however, masonry construction continued elsewhere in the North, in settlements that seemed less affected by the destruction and terror unleashed by Ivan's paranoia. Indeed, Russian expansion into Siberia continued, in large measure due to the efforts of the brilliant and ruthless entrepreneur Anika (Ioannikii) Stroganov (1497–1570). Although in most respects a miser and a cruel master, Anika began the lavish Stroganov patronage of the arts.[7] His wealth was incalculable, from salt refining, trade with the West (through the White Sea), and the exploration—and exploitation—of Siberia. Indeed, Ivan the Terrible allowed Stroganov to maintain an army of his own and to exploit the wealth of vast areas of the Urals and Siberia. In return, the domains of the tsar were greatly expanded at relatively small expense.

Anika Stroganov was devoted to all aspects of church art, and in that spirit he commissioned the last of the major masonry churches of the Russian North during the reign of Ivan the Terrible. The Stroganovs spent immense sums on the arts and crafts in the north of Russia during the sixteenth and seventeenth centuries. The term "Stroganov style" defines elaborately ornamented forms in music, icon painting, and architecture, as well as in the applied arts. This style appeared wherever the Stroganovs had major operations, from Solvychegodsk to Nizhnii Novgorod to Perm in the Ural Mountains.

The Annunciation Cathedral was built at what would seem an improbably remote site for so large a structure, but the settlement of Solvychegodsk ("salt on the Vychegda") was the center of the Stroganovs' commercial empire. Its location near the confluence of the Vychegda and Northern Dvina Rivers endowed it with major strategic significance and great wealth. Work on the cathedral began in 1560 and apparently concluded in the early 1570s, although it was not formally consecrated until 1584.[8]

6. For a survey of Vologda's architectural history, see William C. Brumfield, "Photographic Documentation of Architectural Monuments in the Russian North: Vologda," *Visual Resources* 12 (1996) 2:135–56.

7. The development of the Stroganov fortune in the sixteenth and seventeenth centuries is exhaustively chronicled in A.A. Vvedenskii, *Dom Stroganovykh v XVI–XVII vv.* (Moscow: Sotsekgiz, 1962).

8. On the construction dates of the Annunciation Cathedral, see G. Bocharov and V. Vygolov, *Sol'vychegodsk. Velikii Ustiug. Tot'ma* (Moscow: Iskusstvo, 1983), pp. 24–27.

Figure 5
Cathedral of the
Annunciation.
Solvychegodsk.
1560 to early 1570s.
Southeast view, with
early 19th-century bell
tower on left.
Photograph by William
Brumfield.

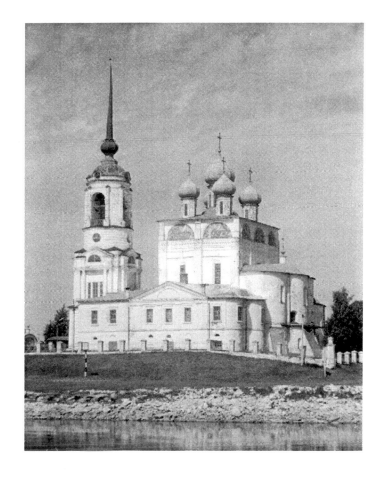

The design of the structure is highly idiosyncratic. Instead of the three or four bays typical for the length of large masonry churches during this period, there are only two. The exterior walls of the structure originally culminated in *zakomary,* whose outlines are still visible beneath a four-sloped roof dating from the eighteenth century (fig. 5). Despite the unusual configuration of its structure, the Annunciation Cathedral has elements typical of Northern architecture, such as the raised parvis on three sides and the decorative brick bands beneath the arches of the *zakomary.* At the northwest corner of the cathedral's exterior gallery, or parvis, there originally stood a large bell tower with its own altar. The tower fell into disrepair, and it was replaced (1819–26) by the current, neoclassical bell tower, which overshadows and defaces the form of the medieval sanctuary.

The ingenuity of the design of this large structure is particularly evident in the interior. Instead of the usual four piers, it has only two, and this resolution truncates the

9. P.I. Savvaitov, *Stroganovskie vklady v Sol'vychegodskii Blagoveshchenskom sobore po nadpisiam na nikh* (St. Petersburg: A. Transhel, 1886). Concerning the iconostasis, see Bocharov and Vygolov, *Sol'vychegodsk*, pp. 43–44.

10. For further discussion of the application of the two-piered system at the gate Church of the Savior-Prilutskii Monastery, see Bocharov and Vygolov, *Vologda*, pp. 134–35.

11. Early twentieth-century photographs and a description of the iconostasis of the destroyed Church of John the Baptist at Diudikovaia Pustyn are contained in Lukomskii, *Vologda v ee starine*, pp. 103–107. On all three two-piered churches in Vologda, see Bocharov and Vygolov, *Vologda*, pp. 122–26.

Figure 6
Cathedral of the Annunciation. Solvychegodsk. View east, with central piers.
Photograph by William Brumfield.

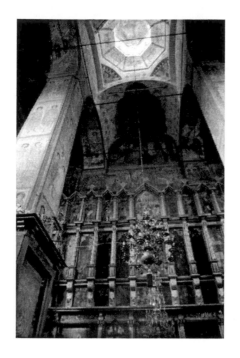

western part of the cross-inscribed plan typical for medieval Russian Orthodox architecture. Even so, the cathedral has five drums and domes that are usual for large sixteenth-century churches (fig. 6). The central drum rises directly over the two main piers, while the four smaller drums and cupolas rest on a complex system of corbelled arches that shift the weight to the outer walls of the church. A large apsidal structure for the altar buttresses the east wall, where the load stress is greatest.

The interior walls of the Annunciation Cathedral were painted with frescoes in the summer of 1600, as noted in an inscription at the base of the walls. They were subsequently overpainted in the eighteenth and nineteenth centuries, particularly after a fire damaged the interior in 1819. Although a restoration effort since the 1970s has uncovered original frescoes on the west wall, most of the first paintings are irretrievably lost. The centerpiece of the Annunciation Cathedral was an elaborate five-tiered iconostasis, originally installed by the end of the 1570s, with more than seventy icons, few of which remain.[9] The iconostasis was rebuilt more than once in the seventeenth century, and its present form dates from the 1690s, although the extant Royal Gates at the center of the iconostasis (leading to the altar) were donated by the Stroganovs at the beginning of the seventeenth century.

The structural peculiarities of the Annunciation Cathedral appeared in similar form in other large churches in the regions of Vologda and Kostroma. At the Savior-Prilutskii Monastery, for example, the gate Church of St. Theodore Stratilates, consecrated in 1590 and rededicated to the Ascension in 1815, applied the two-piered plan on a more modest scale.[10] Of larger dimensions in Vologda itself, there were at least three churches that used a two-piered design: the Church of John the Baptist at Diudikovaia Pustyn (ca. 1653; destroyed in 1932), the Church of St. Nicholas in Vladychnaia Sloboda (1669), and the Church of the Transfiguration (also dedicated to St. Andrew the Apostle; ca. 1670 or perhaps 1687).[11]

One of the latest, and most impressive, examples of the two-piered structural plan in the North appeared in the latter half of the seventeenth century at Trinity-Gleden Monastery, located near the town of Velikii Ustiug. The town itself is situated at the confluence of the Sukhona and Iug Rivers, which form the north-flowing Northern Dvina. As noted above, the Dvina merges with the Vychegda River some 100 kilometers north of Velikii Ustiug, and thus the two settlements were closely linked by a major river artery.

The first documentary references to Ustiug date from the beginning of the thirteenth century, although pioneering traders from Novgorod had probably settled the site of the town by the middle of the twelfth century.[12] Novgorod laid claim to authority over the area until the middle of the fifteenth century, although for most of its early history it was nominally subordinate to the Rostov principality. In addition to being a center of trade, Ustiug supported a vigorous missionary activity on behalf of the Orthodox Church. One of the most remarkable religious leaders produced by Ustiug, St. Stepan of Perm, began work among non-Russian indigenous tribes (primarily Komi or Zyrians) along the Vychegda basin eastward to the Ural Mountains. He became bishop of Perm in 1383 and was canonized shortly after his death in 1397.[13]

At the end of the fourteenth century, Ustiug joined the domains of the grand prince of Moscow and between 1391 and 1425 was consequently subject to frequent attacks by forces loyal to Novgorod. In return, Ustiug launched a number of raids against Novgorodian outposts along the Northern Dvina River. During the second quarter of the fifteenth century, Ustiug was heavily involved in a prolonged struggle among rival princes who were challenging the position of Vasilii II (the Blind) on the throne in Moscow. Ultimately, Ustiug supported the winning cause of Vasilii and gained still further importance as Moscow's main outpost in the northeast. With the development of Russia's trade with England and Holland during the reign of Ivan the Terrible, the position of Ustiug as a river port achieved such importance that the town added the epithet *velikii* ("great") to its name. During the interregnum known as the Time of Troubles at the beginning of the seventeenth century, the town, although damaged, repulsed one major raid and subsequently participated in the campaign that led in 1613 to the enthronement of Michael, first tsar of the Romanov dynasty.

From the preceding historical survey it is apparent that during the late medieval period Velikii Ustiug had acquired considerable wealth and strategic importance, and yet it had few masonry churches, even in comparison with other major settlements of the North, where logs were the preferred building material.[14] No masonry church has survived in Ustiug from before the middle of the seventeenth century, and of the few

12. A detailed survey of the medieval history of Velikii Ustiug is contained in V. P. Shilnikovskaia, *Velikii Ustiug (razvitie arkhitektury goroda do serediny XIX v.),* (Moscow: Stroiizdat, 1973), pp. 8–26.

13. St. Stepan of Perm (Stefan Permskii) was the subject of one of the most reknowned vitae of the medieval Russian church. Written by Epifanii Premudryi (Epiphanius the Wise) in 1396, the *Zhitie Stefana Permskogo* has been the object of much critical analysis, including D.S. Likhachev, *Chelovek v literature drevnei Rusi* (Moscow: Nauka, 1970), pp. 73–80.

14. For an analysis of the physical development of Velikii Ustiug, with special emphasis on the sixteenth through the eighteenth centuries, see Shilnikovskaia, *Velikii Ustiug,* pp. 28–73.

15. Chronicle references to the two raids by Vasilii Kosoi and the Viatchane are contained in A.A. Titov, ed., *Letopis Velikoustiuzhskaia* (Moscow: Trapeznikov, 1889), p. 28.

16. There is no documentary evidence as to the date of the founding of Trinity-Gleden Monastery, but it is clearly one of the earliest monastic institutions in the North. For a discussion of possible dates, see Shilnikovskaia, *Velikii Ustiug*, pp. 113–14.

17. After the death of the first two brothers, the third brother, Vasilii Grudtsyn, was left a bequest by his father-in-law, Filaret (who had become an elder at the monastery), to complete the cathedral's construction. Vasilii did not honor the agreement, and not until the hegumen of the monastery appealed to Patriarch Ioakim in Moscow did Grudtsyn release the money for construction around 1690. See Bocharov and Vygolov, *Sol'vychegodsk. Velikii Ustiug. Tot'ma*, pp. 249–50. Further information on the Trinity-Gleden Monastery and its cathedral is contained in Shilnikovskaia, *Velikii Ustiug*, pp. 113–17. Shilnikovskaia notes (p. 117) that by the nineteenth century, the Trinity Monastery had become so impoverished that it was placed in the care of the Archangel Michael Monastery, and consequently there was no further construction that might have damaged the ensemble created in the seventeenth and eighteenth centuries.

extant seventeenth-century structures, many were substantially modified in the eighteenth and nineteenth centuries. The architectural monuments of Velikii Ustiug can be defined as attractive provincial variations of parish church architecture from central and western Russia, and the city is distinguished primarily by the harmony of its architectural ensembles within the natural setting along the Sukhona River.

The Trinity-Gleden Monastery, although visible from Velikii Ustiug, is situated on the opposite bank of the Sukhona and is some five kilometers to the southwest of the city. In fact, the monastery occupies the site of the area's earliest historical settlement, known as Gleden, but devastating raids in 1436 and 1438 by the forces of Vasilii Kosoi and his allies led to the abandonment of Gleden as a town.[15] The monastery, which was presumably established no later than the middle of the thirteenth century, continued to exist on the site, with its three churches rebuilt in wood.[16] The earliest masonry structure is the monastery cathedral, dedicated to the Trinity (fig. 7). Construction work began in 1659, with the support of a donation by Sila and Ivan Grudtsyn, who were from one of Ustiug's wealthiest merchant families. Subsequent financial and legal difficulties after the death of the brothers halted construction for much of the 1660s until 1690. The structure was finally completed only at the end of the seventeenth century.[17]

The cathedral's design and exterior form owe much to the slightly earlier Cathedral of the Archangel Michael (1653–56) at the monastery of the same name in Ustiug itself (fig. 8). Both are elevated on a high *podklet,* or socle; both have walls that rise to a cornice underlying the curved gable ends, or *zakomary* (a distant derivation from early Italian influence, such as the Archangel Michael Cathedral in the Moscow Kremlin); and each has a level, four-sloped roof placed over the *zakomary* (as opposed to a roofline that follows the contours of the curved gables).[18] Each also has a raised porch, or parvis, attached to all but the east facade. There are other similarities and some differences, such as the position of the freestanding bell tower at the northwest corner of the Archangel Cathedral and directly to the west of the Trinity Cathedral. (The latter is a highly unusual arrangement for a bell tower in relation to a monastery cathedral.)

The major difference between the two main monastery cathedrals of Velikii Ustiug concerns the interior structure. The Archangel Michael Cathedral has four piers in the traditional inscribed-cross arrangement. In contrast, the Trinity Cathedral has two piers in a plan that resembles the Solvychegodsk Annunciation Cathedral of a century earlier. There are, however, significant differences between the latter two struc-

Figure 7
Cathedral of the
Trinity. Trinity-
Gleden Monastery.
Velikii Ustiug.
1659–90s. South
facade.
Photograph by William
Brumfield.

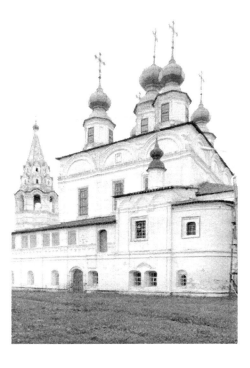

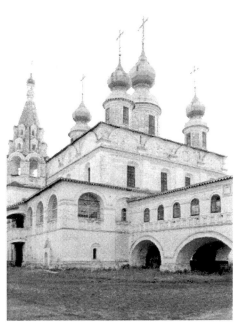

Figure 8
Cathedral of the
Archangel Michael.
Archangel Michael
Monastery. Velikii
Ustiug. 1653–56.
Southwest view.
Photograph by William
Brumfield.

tures. The Annunciation Cathedral has two massive bays on the north and south facades that accurately reflect the interior spatial division, whereas the pilasters that divide the north and south facades of the Trinity Cathedral into three exterior bays surmounted by *zakomary* do not correspond to the interior segmentation. In earlier medieval architecture, this correspondence would have been obligatory, but by the second half of the seventeenth century, developments in vaulting and masonry techniques permitted a divergence between exterior and interior segmentation that is particularly noticeable in churches of the Iaroslavl, Kostroma, and Vologda regions.

The use of the two-piered plan, when implemented with careful calculation of the stress on the exterior walls of large structures such as the Trinity Cathedral, permits a significantly greater illumination of the interior (fig. 9). The piers are relatively compact, as are the spring arches of the vaulting. In addition, all of the five drums are situated over the main interior space. In the typical design of earlier medieval churches, the east drums were placed over bays located behind the iconostasis, and thus diminished the amount of light cast on the main interior space. By the seventeenth century, iconostases were more frequently attached to the upper part of the east wall (above

18. On the architecture of the Archangel Michael Cathedral, see Bocharov and Vygolov, *Sol'vychegodsk. Velikii Ustiug. Tot'ma,* pp. 196–203.

Figure 9
Cathedral of the
Trinity. Trinity-
Gleden Monastery.
Velikii Ustiug.
Interior, east view.
Photograph by William
Brumfield.

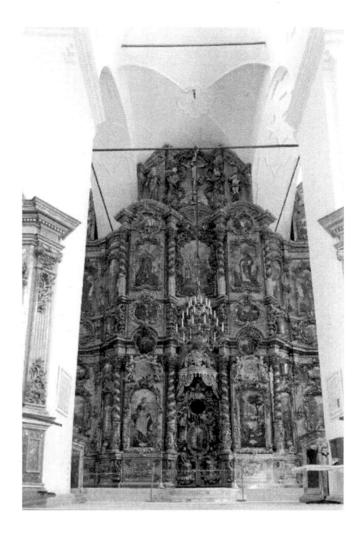

19. Remarks on the
iconography of the Trinity
Cathedral iconostasis and its
relation to Western religious
art are contained in K.
Onash, "Ikonostasy Velikogo
Ustiuga," in V.A. Sablin, ed.,
*Velikii Ustiug: kraevedcheskii
almanakh* 1 (1995), pp. 180–
94. See also G.N. Bocharov,
"Klassitsisticheskie
ikonostasy Velikogo
Ustiuga," in G.G. Pospelov,
ed., *Russkii klassitsizm vtoroi
poloviny XVIII–nachala XIX
veka* (Moscow:
Izobrazitelnoe iskusstvo,
1994), pp. 70–77.

the opening for the eastward projection of the apse) in a design that allowed more light into the main space.

Although the emphasis of this article is on architecture, it should be noted that the interior walls of the cathedral were not painted with frescoes, and the main icon screen, consisting of five rows of intricately carved and gilded wood, was erected only in the late eighteenth century (1776–84). The iconostasis also contains extensive statuary in a baroque style that amplifies the central iconic motif of the ministry and the Passion of Christ.[19] Figured statuary is generally absent from Russian Orthodox

churches; carved figures frequently appear in more elaborate iconostases of the Russian North in the latter half of the eighteenth century. The proliferation of such elaborate iconostases, in large, unpainted churches with spacious interior designs, might perhaps be related to the desire of the merchant donor(s) to place the splendid, costly creation in a structural context that would show it to best effect.

Fortunately, the Trinity Monastery contract with the master craftsmen informs us that they were from the town of Totma, located on the Sukhona River some 200 kilometers to the southwest of Velikii Ustiug.[20] Totma, whose wealth was based on salt refining and trade on the northern river network, supported a flourishing late baroque style in church architecture and decoration in the latter half of the eighteenth century. Its exuberant style is evident in the Trinity Cathedral iconostasis, whose state of preservation is better than that of any of the extant Totma churches. The ultimate sources for this peculiar eighteenth-century combination of florid baroque and neoclassical elements are St. Petersburg and, possibly, the Ukrainian baroque.

The Vologda region, however, had its own florid style in religious art, supported by the Stroganovs and reaching its culmination in Solvychegodsk at the cathedral of the Monastery of the Presentation of the Virgin. Its patron, Grigorii Dmitrevich Stroganov, had by 1688 acquired a dominant position in the Stroganov mercantile empire and would soon figure prominently in the political and cultural changes affected by Peter the Great.[21] Like his ancestors, Grigorii Stroganov had manifold interests in the applied arts, and his workshops continued to produce artistic objects for church use.[22] In 1688 he commissioned a new cathedral to replace one of wood in the monastery that formed part of the family compound at Solvychegodsk. Although the church was not consecrated until 1712, some of the lower parts of the structure were already functioning by 1691, and evidence of work on the iconostasis suggests that the basic construction was completed by 1693.[23]

The Presentation Cathedral is distinctive for many reasons, not the least of which is the elaborately carved limestone decoration that segments the facades of unstuccoed brick in a combination of seventeenth-century Muscovite ornamentalism and an early Russian interpretation of the system of orders (fig. 10). In addition to columns, window surrounds, and scallop shells (above the gables) of limestone apparently carved in Moscow, the facades are also decorated with polychrome ceramic tiles. Other churches of the same period showed similar decorative qualities, particularly the "Naryshkin baroque" tower churches and the Dormition Cathedral at Riazan by

20. Information on the identity of the iconostasis masters (the carvers, the gilder, and the main icon painters) is contained in Bocharov and Vygolov, *Solvychegodsk. Velikii Ustiug. Totma,* pp. 255–57.

21. On the development of the Stroganov fortune in the seventeenth century, see A.A. Vvedenskii, *Dom Stroganovykh v XVI–XVII vv.* (Moscow, 1962).

22. A selection of items produced by the Stroganov workshops from the late sixteenth through the seventeenth centuries is contained, with scholarly commentary, in E.V. Logvinov, ed., *Iskusstvo stroganovskikh masterov* (Moscow: Sovetskii khudozhnik, 1991).

23. Evidence of the construction dates is summarized in Bocharov and Vygolov, *Sol'vychegodsk. Velikii Ustiug. Tot'ma,* pp. 74–75. See also two articles by O.I. Braitseva: "K istorii stroitelstva Vvedenskogo sobora v Solvychegodska," *Arkhitekturnoe nasledstvo* 16 (1967), pp. 55–60; and "Sol'vychegodsk kontsa XVII v.," *Arkhitekturnoe nasledstvo* 24 (1976), pp. 76–82.

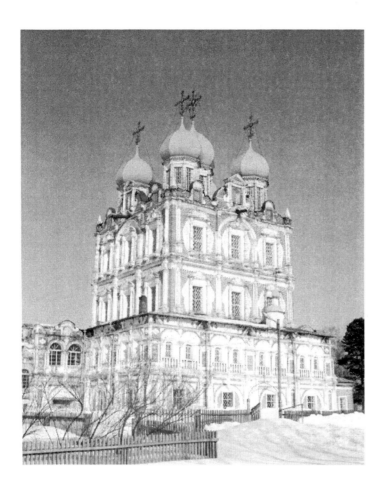

Figure 10
Cathedral of the
Presentation of the
Virgin. Presentation
Monastery.
Solvychegodsk.
1688–90s.
Photograph by William
Brumfield.

Iakov Bukhvostov.[24] The Presentation Cathedral is unique in combining a large cuboid structure, like the Riazan cathedral, with the rich decoration typical of the smaller, compressed tower churches. There were some changes to the exterior, particularly in the eighteenth century when the gallery—originally an open terrace—was enclosed in a brick-and-limestone arcade with an intricate cornice. (Since then it has been obscured by an awkward sloped roof.)

The greatest structural achievement of the Presentation Cathedral, however, is the interior vaulting system, which supports the large structure and its five cupolas with no freestanding piers (fig. 11). Instead, the superstructure rests on a system that can be described as two sets of paired arches springing from pilasters in the center of each wall and intersecting beneath the main cupola drum. This is the first use of such a design for a building this large and with openings for all five cupola drums.[25] The effect is one of extraordinary light and spaciousness, which focuses attention, as at the Trinity-Gleden Monastery cathedral, on the great iconostasis. (Neither structure was painted with frescoes.)

In contrast to the icon screen of the Trinity Cathedral, the seven-tiered iconostasis of the Presentation Cathedral is contemporary with the construction of the building. Indeed, as noted above, the creation of the iconostasis by Grigorii Ivanov in 1693 provides a means of dating the completion of the construction. Its style is typical of the Naryshkin baroque: a gilded wooden frame with an intricately carved grapevine motif. There is also a small amount of statuary that does not, however, have the Western-style baroque fluency of the Gleden iconostasis, which was created almost a century later.

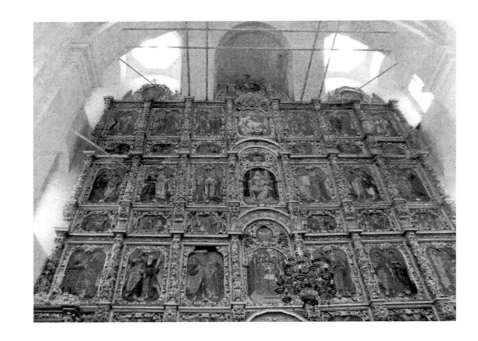

Figure 11
Cathedral of the
Presentation of the
Virgin. Presentation
Monastery.
Solvychegodsk.
Interior, ceiling vaults.
Photograph by William
Brumfield.

24. For a discussion in English of the Naryshkin baroque and late seventeenth-century ornamentalism, see Brumfield, *History,* pp. 184–93.

25. Other seventeenth-century cuboid church structures without interior piers, such as Moscow's Church of the Trinity in Nikitniki and the Church of the Epiphany in Iaroslavl, are not only smaller but their cross-vault design has only one opening in the roof, for the central drum. The other four drums are "blind." See Brumfield, *History,* pp. 147–49, 163. Further analysis of structural features of the Presentation Cathedral is contained in O.I. Braitseva, "Konstruktivnye osobennosti arkhitekturnykh detalei Vvedenskogo sobora v Sol'vychegodske," *Arkhitekturnoe nasledstvo* 14 (1962), pp. 105–108; and Bocharov and Vygolov, *Sol'vychegodsk. Velikii Ustiug. Tot'ma,* pp. 75–76.

The flourishing of commerce and shipping in the large territory of Vologda Province in the sixteenth and seventeenth centuries gave rise to a rich culture that was reflected in local religious art. The masonry churches discussed here represent the variety of forms that were developed during this period, when entrepreneurs in the North could command resources that rivaled those of Russia's major cities. Although the pervasive influence of Moscow church architecture has been noted in the preceding analysis, patrons such as the Stroganovs, and the masters who worked for them, were capable of devising new and striking variations on the traditional forms of Russian church architecture. To some degree, this process of innovative masonry construction continued in the North during the eighteenth century. By that time, however, the great cultural upheaval promulgated by Peter the Great had turned Russian commerce, culture, and architecture toward a different point of orientation, to the new imperial capital of St. Petersburg.

Decorative Arts of the Russian North:
Western Imagery in Provincial Cities

The northern trade route from Moscow to Arkhangelsk was one of Russia's major links to western Europe from 1553, when Ivan the Terrible opened trade with England, until well into the eighteenth century, when it was surpassed by St. Petersburg. The Moscow princes and the Orthodox Church created important outposts in the towns along the rivers to establish their power there and to take advantage of the increasingly lucrative trade opportunities. As these outposts turned into lively trading centers, the local merchants played an increasingly significant role. They built the extraordinary baroque churches, discussed by William Brumfield, ordered icons and fresco paintings for their interiors, and patronized local silversmiths, enamelers, and ivory carvers for their luxury wares. These merchants were the tastemakers of the North, the predecessors of the great Moscow merchant patrons and collectors of the late nineteenth century.

The decorative arts produced by these provincial artisans are distinguished stylistically not only by locale but also by their largely secular nature and the influence of Western ornament and subject matter. Unlike the liturgical and ceremonial plate produced in the seventeenth century in the Kremlin Armory workshops in Moscow, proportionally more of the decorative arts of the North were intended for the toilette, for tea drinking, for the desk, as well as for presentation.[1] Icon *oklady* (icon covers) and gospel covers were made for the church, but such work no longer dominated. Although the secularization of the arts grew throughout Russia in the eighteenth century, these features can already be seen in the enamel bowls, caskets, and perfume bottles produced in Solvychegodsk and the ink pots and candlesticks made in Velikii Ustiug at the end of the seventeenth century.

We know that a few such objects were made for the court, but the majority of them seem to have been intended for the prosperous merchant and bureaucratic classes that populated the northern towns of Iaroslavl, Vologda, Velikii Ustiug, Solvychegodsk, and Arkhangelsk, towns spread along the trade route from Moscow to the White Sea. This is evident not only in the imagery on the objects but also in their relative simplicity compared to pieces made for the court in the same period in Moscow and later in St. Petersburg.

1. This perception is based on existing wares. Many of the luxury secular wares used by the court, especially after Peter moved the capital to St. Petersburg, were imported. Peter himself, as well as his successors, melted down silver to finance their wars. As a consequence, not a lot remains, and some of it is not considered Russian.

Figure 1
Bowl with signs of
the zodiac on the
back. Solvychegodsk.
Late 17th century.
Silver gilt, enamel.
Hillwood Museum
and Gardens,
Washington, D.C.

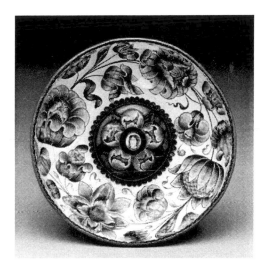

The Westernization and the secularization of the arts in the North coincides with a similar process that was taking place in Moscow during the reigns of the first Romanovs, Tsars Michael and Alexis.[2] Western influences were streaming into Moscow from Poland and Belarus, and after 1667 with the annexation of Kiev, from the more liberal and Romanized Ukraine. An increase in trade with countries to the south occurred as well. Ivan the Terrible's final defeat of the Tatars in 1552 freed up, for both Russians and foreigners, the trade route along the Volga to and from Persia.

Trade brought foreign luxury goods into the North from many directions, and with them came new types of ornament. This proliferation of cultural contrasts has resulted in confusion about the origin of some motifs found on objects. The flowers, for example, that decorate seventeenth-century church vestments or enamel bowls made in Solvychegodsk (fig. 1) were Eastern in origin, from Persia or Turkey, but did they enter Russia via western Europe or directly from the south? Did the prints that were the source for so many images employed in niello and enamel decoration come into the North via Kiev and Moscow or directly from Europe through Arkhangelsk?

At the same time, artisans in Solvychegodsk in particular, but others as well, were exerting their influence on the Kremlin Armory workshops. This is evident in some of the motifs and color palettes found in Kremlin enamels, although far less frequently than in the North.[3] The Armory workmasters could have copied enamels from the North, but more than likely the Armory imported talented artisans from these northern cities when it was at the height of its artistic production at the end of the seven-

2. See James Cracraft, *The Petrine Revolution in Russian Imagery* (Chicago and London: University of Chicago Press, 1997), chap. 3, for a discussion of this phenomenon prior to the reforms of Peter the Great.

3. N.V. Kaliazina, G.N. Komelova, N.D. Kostochkina, O.G. Kostiuk, and K.A. Orlova, *Russkaia emal' XII–nachala XX veka iz sobraniia gosudarstvennogo ermitazha* (Leningrad: Khudozhnik RSFSR, 1987), figs. 18 and 19.

Figure 2
"Stroganov Mansion in Sol'vychegosk." In Nikolai Makarenko, *Iskusstvo drenei Rusi u Soli Vychegodskoi* (Petrograd, n.d.).

4. I.A. Bobrovnitskaia, "Ob emaliakh Oruzheinoi palaty: K probleme proiskhozhdeniia 'usol'skikh emalei'," *Muzei 4* (Moscow: Sovietskii khudozhnik, 1983), p. 63.

5. See Bruce Lincoln, *The Conquest of a Continent: Siberia and the Russians* (New York: Random House, 1994), chaps. 5 and 6 for a history of the Stroganov involvement in conquering Siberia.

6. G. Bocharov and V. Vygolov, *Sol'vychegodsk, Velikii Ustiug, Tot'ma* (Leningrad: Iskusstvo, 1983), p. 16. I.N. Ukhanova, "Knizhnaia illiustratsiia XVIII v. i pamiatniki narodnogo dekorativno-prikladnogo iskusstva russkaia severa," in T.V. Alekseeva, *Russkoe iskusstvo pervoi chetverti XVIII veka: Materiali i issledovaniia* (Moscow: Nauka, 1974), p. 211.

teenth century. Several examples are known of silversmiths from Solvychegodsk being called to Moscow to work on certain projects.[4]

Dominating trade and cultural affairs in the sixteenth and seventeenth centuries was the powerful and wealthy Stroganov family. Arriving in Solvychegodsk in the late fifteenth century, they made their money distilling salt. A century later Stroganov descendants set out to tame eastern Siberia for the crown.[5] In addition to their profits from the salt works, their established outposts in the Urals and Siberia enabled them to reap the benefits of the lucrative fur market. Solvychegodsk became the transit stop where goods from the Urals were moved either north or south, to Arkhangelsk or to Moscow. The Stroganovs were not only merchants and adventurers but also patrons of the arts, building and decorating churches and their own peculiar fortress-mansion (fig. 2). A sixteenth-century description of the rooms in this mansion lists icons in gold and silver *oklady;* copper, silver, and glass dishes; clocks of German workmanship; and rugs of polar bear fur. Musical instruments hung on the wall, and there was even a parrot in a cage. Here in the heart of Russia's forested, frozen North, the Stroganovs had amassed the largest library in Russia in the sixteenth century.[6]

7. Bobrovnitskaia, "Ob emaliakh," p. 58. This assumption was based on the conclusions of N.N. Pomerantsev, a curator at the Kremlin Armory, who was writing in 1925. For a discussion of *Usolsk* enamels, see Anne Odom, *Russian Enamels: Kievan Rus to Fabergé* (London: Philip Wilson, 1996), pp. 36–45; L.V. Pisarskaia, N. Platonova, and B. Ulianova, *Russkie emali XI–XIX vv.* (Moscow: Iskusstvo, 1974), pp. 138–60; and Kaliazina et al., *Russkaia emal'*, pp. 21–22; and Alexander von Solodkoff, *Russian Gold and Silverwork 17th–19th Century* (New York: Rizzoli, 1981), pp. 52–61.

8. Bobrovnitskaia, "Ob emaliakh," p. 58.

9. The inscription on an enameled corner appliqué for a gospel cover translates: "an usolets (a person of Usole) icon painter painted [this plaque]." This inscription identifies the artist with the town and not with the Stroganov workshops. Penelope Hunter-Stiebel, ed., *Stroganoff: The Palace and Collections of a Russian Noble Family* (New York: Harry N. Abrams, 2000).

10. N.T. Tikhomirova, "Ustiuzhskie emali XVIII v. s serebrianymi nakladkami," *Trudy gosudarstvennogo istoricheskogo muzeia* XIII (Moscow, 1941), p. 192.

The family supported workshops for icon painting and embroidering liturgical textiles. The earliest icons reflect the style of Novgorod, the province in which Solvychegodsk was originally located. By the seventeenth century, Stroganov icons were distinguished by the elongated lines of the figures and the intricate detailing of the vestments, perhaps indicative of the influence of Persian miniatures that must have been among the works collected by the family. The family's textile workshops produced vestments and altar cloths for the Stroganov churches in Solvychegodsk, but the family also presented altar cloths to churches in Iaroslavl, Rostov, and as far down the Volga as Nizhnii Novgorod.

At this time the Stroganov workshops competed with the workshops of the Kremlin Armory as an artistic center, an indication of the sophistication of the Stroganov dynasty. In addition to their workshops, there were also independent silversmiths working in Solvychegodsk already in the late sixteenth century, supplying *oklady* to decorate the local church icons. For most of the twentieth century it was assumed that the enamelwares made in Solvychegodsk, called *Usolsk*, were also made in the Stroganov workshops.[7] It is now believed that these enamels were made in the silver row (*serebriannyi riad*) in the bazaar of the town's *posad,* or merchant quarter, and not in the Stroganov workshops.[8] While documents link icons and liturgical textiles to the Stroganovs as patrons or donors, no such evidence has been found that enamels were made in their workshops or were indeed owned by or presented by them.[9] Russian scholars estimate that these *Usolsk* enamels were made in the 1690s. If so, production of these wares was at its height at the very moment when the Stroganov operation was moving east to Perm. The lively trading environment of the town and its reputation as an artistic center must have attracted silversmiths who created wares to be sold at one of the three fairs held annually in Solvychegodsk. As a foreign envoy noted in 1692, Solvychegodsk not only had "rich traders and educated artists, but even more, masters of silver and brass work."[10] Their production was large. Irina Bobrovnitskaia, curator at the Kremlin Armory who has extensively studied *Usolsk* enamels, estimates that there are about 200 examples in Russian collections alone, a remarkably large number that are still extant. These enamels represent the last artistic achievement of a town that was about to lose its power.

Most of the production is in the form of bowls, cups, caskets, and perfume bottles. The technique of painted enamel, as distinguished from the more traditional techniques of *cloisonné* and *champlevé*, was introduced to Russia from the West, probably from Germany, in the second half of the seventeenth century. Enamels from

11. See *Vystavka drevne-russkogo iskusstva ustroennaia v Moskve 1913 godu* (Moscow, 1913), nos. 62, 63, and 80 for examples of church textiles from Turkey, and nos. 71 and 72 for examples from Persia. Russia also imported fabric from Venice, which had been trading for Turkish fabrics since the fifteenth century.

12. Examples of his work can be found in W.B. Honey, "Johann Heel: Some Newly Identified Works," *The Burlington Magazine* (June 1935), pp. 266–71. Such baroque flowers can also be found on manuscripts copied out by the Old Believers of Pomore. According to I.N. Ukhanova, these manuscripts may have been a source for flower decoration on distaffs and other wooden wares. See Ukhanova, "Knizhnaia illiustratsiia," p. 211, ills. 141 and 142. The two examples she uses postdate the *Usolsk* enamels, but there may well have been earlier ones.

13. Pisarskaia et al., *Russkie emali*, fig. 83.

Solvychegodsk are easily distinguished by their brightly colored flowers, animals, birds, and figures painted on a white opaque ground (fig. 1). Birds and animals can sometimes be found on Kievan wares of the eleventh century, but never on the luxury wares of the Kremlin Armory. Baroque emblematic symbolism, which permeated all Western imagery in this period, was especially popular in the Russian North. On the back of this bowl are raised enamel reserves with allegorical figures representing the seasons, while smaller reserves enclose the signs of the zodiac.

The large, freely painted flowers—tulips, lilies, cornflowers, poppies, and sunflowers—are surely Persian in origin. The question is whether this type of flower ornament was introduced into Russia directly from Persia. Silks for church vestments were being imported in this period from Persia, Turkey, and Italy and are a likely inspiration for this type of flower ornament.[11]

These flowers are ubiquitous, however, on seventeenth-century German silver, and examples of painted enamel flowers on a white ground can be found on Western objects, but not in large numbers. The work of the Nürnberg goldsmith Johann Heel may also be a source for the *Usolsk* flowers, especially as they are enameled on a white ground.[12]

A few bowls have, as an additional part of their decoration, silver appliqués in relief (fig. 3). Such appliqués were apparently used in Ukraine as a decorative element. In the collection of the State History Museum in Moscow is a bowl with the figure of a man holding a manuscript with a text written in Ukrainian, a clue that Ukrainian masters were working in the North.[13]

Biblical subjects also appear on *Usolsk* enamels, although more rarely. The only known source of these Old Testament stories is the Piscator Bible, which was translated into Russian in the 1670s. This illustrated Bible, printed by Nicholaus Johannes Piscator (Klaus Jans Fischer, 1586–1652) in Amsterdam in 1643, was a popular reference for copying. For instance, scenes from the Piscator Bible can be seen in the frescoed interior of the Church of St. Elijah in Iaroslavl and the Church of St. John the Baptist in Tolchkovo, a suburb of Iaroslavl. A large bowl, now in the Walters Art Gallery (fig. 4), is decorated around the sides with scenes from the Book of Esther while an image of King Judah and the lion decorates the center.

The Book of Esther focuses on her protection of Mordecai and the Jews. Esther was a familiar symbol in Russian culture in this period as a reference to Peter's mother Natalia, who for seven years had shielded him from his half-sister Sophia, who was struggling to gain supremacy. The inscription on the plaque at the bottom around

Figure 3
Bowl with portrait of
a man.
Solvychegodsk. Late
17th century. Silver
gilt, enamel.
Walters Art Gallery,
Baltimore, Maryland.

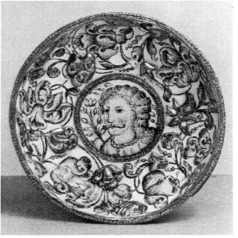 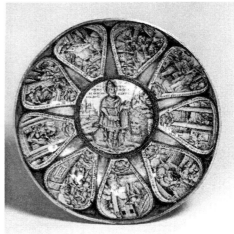

Figure 4
Bowl with Judah and
the lion. Moscow (?).
Late 17th century.
Silver gilt, enamel.
Walters Art Gallery,
Baltimore, Maryland.

Judah's head identifies him as "Jacob's son, from whom descended Christ." The inscription on the right pronounces, "Judah said firmly that he will triumph over the enemies of the lion." Judah represents Peter's royal lineage that will prevail over all. The lion can be seen as Peter's ally and a symbol of his courage. Because of the complicated painting and the allegorical scenes from the Book of Esther, it is likely that this bowl was the work of Moscow artisans. Another bowl in the Kremlin Armory is identical in design and execution, with scenes relating to the Old Testament figure of Rehoboam. Armory curator Irina Bobrovnitskaia also interpreted these images as allegorical references to political events of the 1690s.[14] While these bowls may be the work of Moscow workmasters, they surely show the influence of *Usolsk* enamels on Moscow silversmiths.

Two other known examples of the use of Piscator's illustrations appear on what are clearly Solvychegodsk works. One is a casket with a double portrait on the lid and a scene inside from the Book of Genesis depicting Joseph and Potiphar's wife.[15] A bowl in the collection in the State Hermitage has the same image.[16] Potiphar was an official of the pharaoh, who had entrusted the running of his estate to Joseph, a Hebrew slave. Potiphar's wife tried to lure Joseph to sleep with her. Although Joseph resisted the temptation, she was able to pull off his coat and then convince her husband that Joseph had seduced her. Such a scene was surely employed on a decorative object for symbolic reasons. Perhaps the casket and the bowl were wedding gifts intended to remind the husband that the Lord was with the incorruptible Joseph, who would not be seduced.

14. I.A. Bobrovnitskaia,
"Emalevaia chasha iz
kollektsii Oruzheinoi palaty,"
Muzei 8 (Moscow: Sovietskii
khudozhnik, 1987), pp.
111–21.

15. See Sotheby's London, 17
June 1993, lot no. 665.

16. Kaliazina et al., *Russkaia
emal'*, fig. 54.

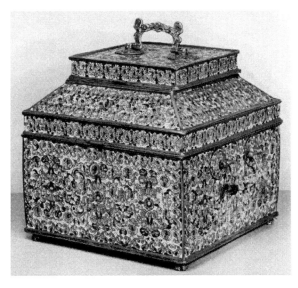

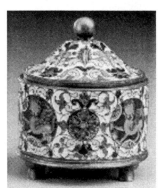

17. Bocharov and Vygolov,
Sol'vychegodsk, pp. 89 and
92.

18. For more on enamels
from Velikii Ustiug, see
Odom, *Russian Enamels,* pp.
46–63, and Tikhomirova,
"Ustiuzhskie emali," pp.
191–216, and examples in
Kaliazina et al., *Russkaia
emal',* figs. 106–13.

With the decline of Solvychegodsk, many silversmiths moved to Velikii Ustiug. This town had also served as a trade center for the Stroganovs throughout the seventeenth century. By 1683 silversmiths occupied twenty stalls in the so-called silver row (*serebriannyi riad*), one of eight trading rows in the local bazaar. (Others were for tanning leather, distilling wine, and brewing beer.) By the end of the eighteenth century more than ten guilds (*tsekhy*) were in existence, including guilds for icon painters, silversmiths, tailors, and iron workers. The town had both a Russian and a foreign *gostinyi dvor,* or covered bazaar, as well as a *nemetskaia sloboda,* or foreign section of town.[17]

The style developed in Velikii Ustiug is quite distinctive and unlike that of Solvychegodsk.[18] These enamels have a strong white ground in contrast to the predominately blue, green, yellow, and black abstract decoration. The technique is also different. The objects are cast brass with ribs separating the enameled colors that are poured into the small holes and fired at low temperatures. The earliest extant objects are utilitarian—caskets and objects for the desk—but a large variety of crosses and *oklady* have also survived. The casket from the Walters Art Gallery (fig. 5) would once have contained jewelry or facial powders and creams, either one testifying to the wealth of the owner.

An enormous number of desk accoutrements were also made (fig. 6). In the rooms occupied by Peter the Great in his palace in the Summer Garden in St. Petersburg or

19. Several known Russian candlesticks have remarkable similarities to English enamels known as Surrey enamels, which may have been imported in this period. For a Russian version, see G. Vzdornov, *Vologda* (Leningrad: Aurora Art Publishers, 1972), fig. 82, and for a Surrey enamel, see Susan Benjamin, *Enamels* (Washington, D.C.: Smithsonian Institution, 1983), fig. 77. Because the process of enameling cast copper alloy was not terribly sophisticated, it is possible that there were other Russian centers in addition to Velikii Ustiug.

20. See Kliazina et al., *Russkaia emal'*, fig. 60. On the metal icons and crosses of the Old Believers, see Odom, *Russian Enamels*, pp. 64–65; Richard Eighme Ahlborn and Vera Beaver-Bricken Espinola, *Russian Copper Icons and Crosses from the Kunz Collection. Castings of Faith* (Washington, D.C.: Smithsonian Institution Press, 1991); and M.N. Printseva, "K voprosu ob izuchenii staroobriadcheskogo mednogo lit'ia v muzeinykh sobraniiakh," *Nauchno-ateisticheskie issledovaniia v muzeiakh. Sbornik nauchnykh trudov* (Leningrad, 1986).

21. See Aileen Dawson, "Gold foil decoration on enamel, glass and porcelain," *The Burlington Magazine* (May 1990), pp. 336–42.

at Mon Plaisir at Peterhof, similarly decorated inkwells or candle holders of this type can be found.[19] This suggests that these practical objects were not only sold locally but were also made for export to Moscow and St. Petersburg. It goes without saying that a large number of ink pots and candle holders for the desk presupposes a literate clientele.

The Old Believers of the Pomore region, located between Lake Onega and the White Sea, were artisans skilled at making cast metal icons and crosses decorated with low-fire enamels. It is not known the degree to which Old Believers were active as metalworkers or silversmiths in Velikii Ustiug or even Solvychegodsk, but it is worth further study. An *Usolsk* bowl in the Hermitage collection, with an isolated hand in a two-finger blessing as the central motif, suggests that Old Believers may have been involved as patrons.[20]

By the mid-eighteenth century Velikii Ustiug was producing another type of everyday enamelware, namely, tea sets (fig. 7), coffee pots, trays, and toilette boxes. These pieces, generally made of copper, were covered with an overall single-colored enamel, usually white, turquoise, or dark blue. To create the decoration, small appliqués of a very thin silver foil were applied to the enamel before final firing. Appliqués used on a white ground were often enameled to provide some color to the object. This technique of adding appliqués probably came from Berlin, where Alexander Fromery devised such decoration for enamels in the early eighteenth century.[21] The appliqués on Western objects, however, were generally gilded.

Appliqués allowed for an enormous variety of pictorial representations. One of the favorite print sources, not only for these enamels but also for ivory carvings, was a grammar of symbols, called *Symbola et emblemata*. In 1705 Peter the Great ordered a new edition of the volume to include Russian descriptions of the symbols as well as other European languages. The image of a cupid holding a letter in his hand on a teapot (fig. 7) is identified in *Symbola et emblemata* with the motto "Parfait [or perfect] love aims but at one." This particular teapot is made of silver rather than copper, and the silver ornament that shows is actually a low-relief decoration with tooled and engraved details. The background spaces have been filled with enamel, but the effect is very much like that of the appliqués.

This type of enameled ware was an obvious response to the fascination for porcelain, which at mid-century remained too expensive for anyone other than those at court. These objects were clearly intended for the merchants and nobility, who, although wealthy, could not yet afford or did not have access to porcelain wares.

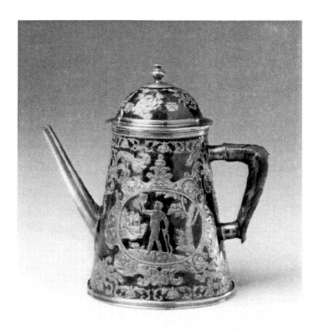

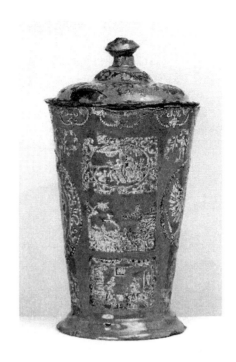

Figure 7
Teapot. Velikii Ustiug.
Mid-18th century.
Copper, silver,
enamel, wood.
Private collection.

Figure 8
Covered cup. Velikii
Ustiug. 1744. Copper,
enamel, silver.
Walters Art Gallery,
Baltimore, Maryland.

Elizabeth I founded the Imperial Porcelain Factory in 1744, but it was not producing tea sets and coffee pots in any number until the middle of the 1750s. Enameled wares thus filled a temporary void. When porcelain became less expensive and more widely available at the end of the eighteenth century, this type of production disappeared altogether.

This is not to say, however, that none was made for the court. In fact, they were sometimes known as "Elizabethan enamels." Numerous trays and cups with the double-headed eagle on them may have been presentation pieces (fig. 8). One cup in the Walters Art Gallery has the eagle on one side and on the other a cipher, possibly that of Peter, Duke of Holstein-Gottorp, the future Peter III. The cup is dated 1744 on the bottom, the year Catherine came to Russia from Anhalt-Zerbst to marry Peter. The existence of another cup just like it, now in the Hermitage, suggests it was a souvenir of that event.

In addition to the imperial symbols, charming genre scenes decorate the sides of the cup. At the top is Orpheus, who is enchanting the surrounding animals by playing his lyre. This image can be found on a number of other pieces, including a large pewter bowl (fig. 9). The appliqués were made in molds, so they were extremely easy

Figure 9
Bowl. Velikii Ustiug.
Second half of 18th
century. Pewter,
enamel, silver.
Walters Art Gallery,
Baltimore, Maryland.

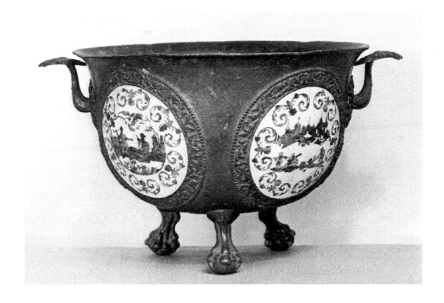

22. For another box at the
Metropolitan Museum of
Art, see Wolfram Koeppe,
"Chinese Shells, French
Prints, and Russian
Goldsmithing: A Curious
Group of Eighteenth-
Century Russian Table
Snuffboxes," *Metropolitan
Museum of Art Journal* 32
(1997), pp. 207–14. I am
grateful to Dr. Koeppe for
information on the shell, its
inscription, and the print
source. See also Anne Odom
and Liana Paredes Arend, *A
Taste for Splendor: Russian
Imperial and European
Treasures from the Hillwood
Museum* (Alexandria, Va.:
Art Services International,
1998), cat. no. 57.

to reproduce in large numbers. (There are more than three hundred pieces of this type of enamel in Moscow's State History Museum alone.)

Contemporary events were also popular subjects for these appliqués. On this same pewter bowl is a scene of soldiers besieging a fortified town. The scene was probably taken from prints depicting events from the Seven Years War. This image as well as the one of Orpheus playing his lyre on the back appear in the form of appliqués on various objects. The pewter bowl itself, with its leaf-shaped handles and three ball-and-claw feet, reveals the influence of wares coming into Russia from China as trade with that country increased in the middle of the eighteenth century. In 1727 Russia formalized this trade through the city of Kiakhta. The ball-and-claw feet are a peculiar English Chippendale element mixed with the Chinese.

Velikii Ustiug was not only a center of enamel production; it was even more famous for silver wares decorated with niello. By the mid-eighteenth century these niello objects were created for the local merchant class as well as for sale in St. Petersburg. Snuffboxes with a shell bottom and a lid of silver decorated, in this case, with a nautical scene in niello (fig. 10) were a specialty of Ustiug silversmiths. The shells were green turbon shells imported from China, where they were used as wine cups. Exotic shells were prized in Europe in the seventeenth century, and they retained this appeal in Russia. This is one of two such boxes in the Hillwood collection. One of these has a Chinese inscription on it that reads, "Your honor, wine in your cup."[22] No other

Figure 10
Snuffbox. Velikii
Ustiug. 1750s–60s.
Silver gilt, niello,
turban snail shell.
Hillwood Museum
and Gardens,
Washington, D.C.

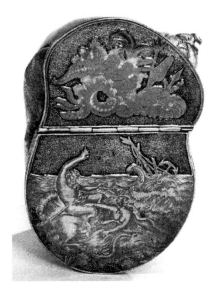

objects reveal more clearly the international position of Velikii Ustiug than this box. The image on the lid is taken from a French print, called *Naufrage*, or Shipwreck, by Jacques de Lajoue and dates from 1736. The print appeared in a volume of fantastic images intended for use in the decorative arts.[23] There are four known boxes with this image, and many others have gallant scenes. The large number of such boxes and their sometimes identical images indicate their popularity as souvenirs of this northern city.

In the mid-eighteenth century, when foreign masters residing in St. Petersburg were making gold boxes in the French manner for the court, niello was viewed as a somewhat old-fashioned technique, and almost none was produced in the capital. Most niello ware was made in either Moscow or Velikii Ustiug. The Ustiug masters had such an excellent reputation that they were invited to Moscow to train masters in their craft.[24] Most enamel and much niello ware from Velikii Ustiug is without a maker's mark. Several names are known, in particular, the factory of the brothers Afanasii and Stepan Popov. Founded in 1761, it produced both enamels and niello until 1776 when, after several natural disasters, a fire closed the factory for good.

Velikii Ustiug's mastery of niello ware was passed on to several other provincial cities, notably Arkhangelsk, Viatka, Vologda, and the Siberian city of Tobolsk. In Tobolsk, which in the second half of the eighteenth century was the administrative center of Siberia, local silversmiths seem to have been patronized largely by Denis Chicherin, the governor of that province from 1763 to 1781. Numerous objects bearing his coat of arms were produced there. These objects feature images of grand ladies and gentlemen, which are clearly taken from Western print sources. Hillwood has three *charki,* or vodka cups, with the Chicherin coat of arms on them and his initials in Latin letters on the front (fig. 11).[25] His shield encloses a sable (an important staple of the Siberian fur industry) and a crossed sword and arrow. Most of the pieces from this service retain rococo elements that were still popular in the 1770s, no doubt

23. *Livre nouveau de douze morceaux de fantasie utile a divers.* This publication enjoyed wide circulation after it was published in Paris in 1736.

24. For examples of Ustiug niello objects of this period, see M.M. Postnikova-Loseva, N.G. Platonova, and B.L. Ulianova, *Russkoe chernevoe iskusstvo* (Moscow: Iskusstvo, 1972), figs. 57–74.

25. For other pieces from this service now in the State Hermitage, see Z.A. Berniakovich, *Russkoe khudozhestvennoe serebro XVII-nachala XX veka* (Leningrad: Khudozhnik RSFSR, 1977), figs. 86 and 87.

Figure 11
Pair of *charki.*
Tobolsk. 1774–75.
Silver gilt, niello.
Hillwood Museum
and Gardens,
Washington, D.C.

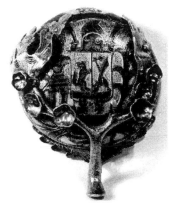 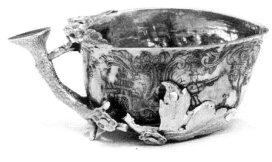

a result of the town's distance from the capital. Such works nevertheless reveal the high quality of workmanship that was available in provincial cities in eighteenth-century Russia.

Although Velikii Ustiug was in decline by the end of the eighteenth century, it continued to produce boxes with maps of the Vologda Province and of the northern towns (fig. 12). These should perhaps be viewed as the last gasp of the North to advertise itself and its former greatness. A large number of these souvenir boxes of the Vologda Province have survived, including two at Hillwood. Each has a map of the province on one side with a *verst,* or mileage chart, at the bottom like an old ESSO map. On the bottom of the box are all the statistics of the province: its geographical location and its population, including the number of merchants and peasants of various kinds, as well as churches, monasteries, and factories. These are among the last souvenirs of the North. By the end of the nineteenth century, Velikii Ustiug masters could not compete with the large Moscow firms of Sazikov, Ovchinnikov, and Khlebnikov. By the beginning of the twentieth century, only one niello master still worked in Velikii Ustiug.

All the centers discussed so far were famed for their metalwork. Kholmogory, about thirty miles south of Arkhangelsk, was known for its ivory carving, dating back to the fifteenth century.[26] The region exported walrus ivory tusks to Europe, where they were carved with elaborate religious scenes. Kholmogory was, like other northern cities along the trade route, a sophisticated center. Mikhail Lomonosov, a scientist, poet, and courtier during Elizabeth's reign, learned carving from Ivan Shubin, whose son Fedot became Russia's most famous sculptor of the eighteenth century.

26. For more on ivory carving, see I.N. Ukhanova, *Rez'ba po kosti v Rossii XVIII–XIX vekov* (Leningrad: Khudozhnik RSFSR, 1981), and V.M. Vasilenko, *Severnaia reznaia kost'* (Moscow: Vsesoiuznoe kooperativnoe izdatel'stvo, 1947).

Figure 12
Snuffbox. Velikii
Ustiug. 1817. Silver
gilt, niello. Hillwood
Museum and
Gardens,
Washington, D.C.

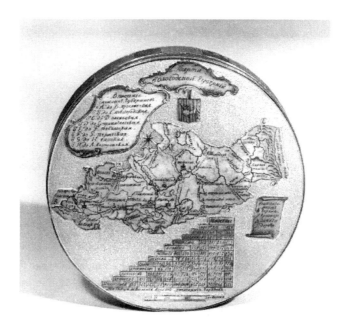

Kholmogory gained particular fame as a center of ivory carving in the eighteenth century. Carved ivories were bought and sold at the large summer fair at Arkhangelsk.

To create boxes and caskets, thin strips of ivory were pinned onto a wooden carcass. These small ivory plaques could be decorated in several ways. They could be incised with floral or geometric motifs, which were sometimes stained green or reddish brown. Ivory masters were particularly adept at openwork carving. Brightly colored foils or silks were placed behind the openwork to enliven the design, thus making these boxes originally much brighter than they are now.

Most of the boxes and chests were intended for jewelry or as containers for powders and creams. A chest in the shape of a secretary was especially popular. The slant front on a chest at Hillwood (fig. 13) drops open to reveal several drawers. Although working in a different medium, the ivory carvers employed some of the same print sources as the silversmiths, especially *Symbola et emblemata*. One carver ordered seven copies of *Symbola et emblemata* from Moscow in 1718, an indication of the wide use of this volume.[27] On the drop front are two plaques with a falcon pursuing a hare. It is derived from an image with the motto "I do it willingly," symbolizing independent action.

Hunters and hunting scenes are also found as subjects of carved panels on caskets. Such scenes, found on niello ware as well, are a reminder of how closely the people

27. Ukhanotva, *Rez'ba po kosti*, p. 27.

Figure 13
Jewel box.
Kholmogory.
Mid-18th century.
Walrus ivory, wood,
silk. Hillwood
Museum and
Gardens,
Washington, D.C.

in these northern cities lived to the wilderness, where hunting game was as much a part of their daily lives as was overseeing their trading activities.

Russian scholars often refer to this type of carving as folk art, when it was in fact luxury art for sale. For example, numerous imperial commissions, especially of ivory, are known. That is not to say that some ivory carving could not be classified as folk art. *Lubki,* or folk prints, are often cited as a source of images on ivories, and certainly many Western prints were transmitted to the lower classes via *lubki,* where they were simplified. I think, however, that most of these images originally came from Western print sources and are not watered-down versions copied from *lubki*.

The print sources used by Northern silversmiths and ivory carvers are clear evidence that they were very much in touch with the Western world, whether through the port at Arkhangelsk or from Moscow or St. Petersburg. These towns were not lazy provincial backwaters in the seventeenth and eighteenth centuries, but they were familiar with the latest styles and print sources from the outside world. By the nineteenth century they no longer had the continued stimulation that trade and its accompanying wealth brought. The masters who remained could no longer compete with the large firms in Moscow and St. Petersburg that catered to the luxury trade.

What remains are the artifacts of a once-prosperous society, closely integrated with the West through the goods that changed hands at the annual fairs or were sold in the local bazaars. The seventeenth-century objects remain a tribute to a time when northern Russia was as much in touch with the Western world as Moscow was. Those pieces from the eighteenth century reveal that these northern towns did not relinquish their western contacts to St. Petersburg quickly or easily. It took over a century for this process to occur.

Northern Visions
Experience and Imagery

ALISON HILTON

The Russian North is both a geographical region and a cultural concept, a frontier comparable to the American West in its complex spectrum of connotations. In other essays in this volume, Abbott Gleason examines changing perceptions of the North in Russian history, while William Brumfield and Anne Odom describe and interpret features of Russian architecture and decorative arts that reveal the northern masters' surprisingly wide scope of resources and contacts. A subtheme of these papers and of my own study is that a sense of the Russian North depends upon one's vantage point, from within or from outside. Specifically, the art of northern Russia encompasses two overlapping elements: art made in the region by people who lived there, and art about the way outsiders responded to the North. This essay is organized around these two viewpoints: that of the inhabitants, as reflected in folk art; and the impressions of artists who came in search of unfamiliar aspects of nature or of local customs and beliefs.[1] By approaching the Russian North from two distinct perspectives, we realize that the environment affected artistic expression in differing ways. Moreover, we may be able to distinguish certain aspects of Northern life that seemed to influence all artists who experienced this region.

Folk Art of Northern Russia

Russia is a land of forests, especially in the North. Rivers and lakes were the main routes of travel and sites of settlement. An early seventeenth-century map shows dozens of towns at landing sites edging the White Sea and along the Northern Dvina, Sukhona, Mezen, and Volga Rivers. Many of these riverside villages, such as Permogore and Navolok, depicted in watercolors and photographs made in the nineteenth and early twentieth centuries, were centers of Northern carving and painting. Today, a few villages and architectural preserves contain the remarkable wooden churches built by peasant carpenters using only their adzes to shape the wood. They have as well the windmills, other farm buildings, and the large dwellings that housed twenty or more people along with livestock, a necessity in the severe winters.[2] The layout of the villages and the furnishings of the houses reflect the people's daily lives and seasonal tasks. In addition, inside every house, decorated cupboards, tools, and utensils provide a wealth of information about the Northern way of life.

1. This discussion is limited to the folk art of Russian settlers in northern territories. For arts of indigenous peoples of northern European Russia and Siberia, see Tatyana Razina, Natalia Cherkasova, and Alexander Kantsedikas, *Folk Art in the Soviet Union* (Leningrad and New York: Aurora and Abrams, 1990), pp. 121–51. Although some overlapping in materials and styles can be observed, especially in the arts of bone carving and work in birch bark, such relationships are beyond the scope of this essay. Most of the material on northern Russian folk arts is based on Alison Hilton, *Russian Folk Art* (Bloomington: Indiana University Press, 1995).

2. Aleksandr Opolovnikov and Yelena Opolovnikova, *The Wooden Architecture of Russia: Houses, Fortifications, Churches* (New York, 1989), and Alison Hilton, "Izba," in *Encyclopedia of Vernacular Architecture of the World*, ed. Paul Oliver (Cambridge: Cambridge University Press, 1997), 2.III.9-B.

3. I. Rabotnova, "Mnogoznachnost' soderzhaniia: Voprosy izucheniia narodnogo iskusstva," *Dekorativnoe iskusstvo SSSR*, no. 11 (1973), pp. 28–29.

4. See S.K. Zhegalova, "Novye materialy po istorii severodvinskoi rospisi," in *Russkoe narodnoe iskusstvo severa. Sbornik statei* (Leningrad, 1968), pp. 34–44. For relations between traditional Old Believer liturgical arts and folk arts, see the exhibition catalogue *Kul'tura Staroverov Vyga [Culture of the Old Believers of Vyg]*, (Petrozavodsk: Karpovan Sizarekset, 1994).

5. State Historical Museum, Moscow. Serafima Zhegalova's rediscovery of Iarygin is recounted in S.K. Zhegalova, "Ekspeditsiia Gosudarstvennogo Istoricheskogo Muzeia na severnuiu Dvinu," *Sovetskaia Etnografiia*, no. 4 (1960). See Hilton, *Russian Folk Art*, pp. 52–53, 190–91.

The *izba*, or peasant house, is defined by a large clay oven dominating the main room. Adjacent to it are benches, shelves, and cupboards, often painted with geometric patterns, flowers, or animals and fantastic creatures. The same motifs were carved on exteriors, especially in the Volga region. Besides the lion, we find the mythical *rusalka* (with a woman's face and a fish tail) and *sirin* (with bird's wings). These creatures adorn embroidered towels hung over windows and icons and various household implements, such as distaffs and serving dishes. The *kovsh*, a large, boat-shaped vessel, was usually carved and painted as a water bird. A bird could become a salt cellar, with jaunty designs of feathers and water plants, and with wings that slide open to hold the salt. One museum curator, on an expedition to northern Russia, admired a duck-shaped salt cellar in a house, but the owner refused to sell it, because, "without it," she said, "the house would be impoverished."[3] Bread and salt symbolized hospitality. Offered to guests on an embroidered towel, bread was stored in bast boxes that were also beautifully decorated. The large, flat surfaces were ideal for a variety of scenes of daily life: hunting, berry picking, taking a carriage ride, weaving and spinning, and finally, on the lid, relaxing and drinking tea. A cradle, painted on all sides with similar scenes, points to observations of real people, perhaps the artist's family.

The inscriptions on many of these objects indicate that the peasants who made them or owned them were literate. Many were in fact descendants of settlers from Novgorod and belonged to the Old Believers sect. Depictions of schoolrooms and a manuscript writing workshop reinforce this aspect of Old Believer culture.[4] The words also remind us that such pieces were made to order by artists who were recognized for their special skills. Far from being an anonymous, instinctive expression of a Russian love for color and ornament, as romantic theorists believed, folk art represents a delicate, shifting balance of local decorative traditions and individual creativity, what I call cumulative originality.

The works just described were made in a few villages on the Northern Dvina River, namely, Navolok, Borok, Mokraia Edoma, and Permogore. We know the names of many artists and families whose members practiced their crafts for generations. One of them, Iakov Iarygin, painted the first known self-portrait by a peasant artist in 1811.[5] As part of the decoration on a birch-bark canister, the artist is shown in his workshop, surrounded by his paints and tools, as he puts the finishing touches on a shaft bow for a yoke of horses. Iarygin and other Permogore artists decorated most of their distaffs, breadboxes, and other objects with engaging views of local life and festive events, such as the visits that were part of courtship rituals throughout the North.

One of the earliest surviving folk paintings shows a young man riding up to the

Figure 1
Distaff. Details of
"Courtship" (front)
and "Newly-weds;
Sleigh Ride" (back).
Arkhangelsk
Province, Borok,
Skobeli village. Late
18th century. Painted
wood. State Historical
Museum, Moscow.

6. State Historical Museum,
Moscow. Zhegalova, "Novye
materialy," pp. 36–37. See
Hilton, *Russian Folk Art*, pp.
187–89.

house of his intended bride. Her bearded father climbs the stairs to fetch her from her room behind one of the windows on the elegant facade (fig. 1).[6] On the reverse side is the sequel: it shows a sleigh ride through a landscape burgeoning with flowers, symbolic of marriage and fertility. Although we don't know who the artist was, the inscription dedicates the piece to "Stepanaida Dmitrovna Chiurakova, silverworker of Kurgomenskaia Volost," indicating that the young woman herself practiced a craft. Distaffs were often given as betrothal or wedding presents, so this kind of decoration makes sense. Sometimes they show fluttering birds or the *sirin* encouraging the suitor, or they describe an elaborate three- or four-story house, colorful to the point of fantasy. Such refinements were in keeping with the formality of the wedding ceremony, at which the peasant groom and bride were called "prince" and "princess," and the guests were "boyars," as if they were characters in a Russian fairly tale.

Later distaffs show a fascinating range of social interactions, sometimes combining traditional compositions with contemporary details. Distaffs from the Mezen River area of Arkhangelsk Province often include sleigh rides or river barges, sometimes with identifying names or numbers. An especially lively scene on a distaff from a village near Mokraia Edoma on the Northern Dvina River shows the steamship *Nevka* with signal flags flying, one sailor on deck and a larger figure standing at attention to

Figure 2
Distaff. Detail of
"Scenes from a Sailor's
Life." Arkhangelsk
Province, Mokraia
Edoma village group.
Second half of 19th
century. Painted wood.
Sergeev Posad
Museum-Preserve.

7. I am indebted to Serafima
Zhegalova and Svetlana
Zhizhina for introducing
these works to me and shar-
ing information about the
artists. See S.K. Zhegalova,
"Khudozhestvennye prialki,"
in S.K. Zhegalova et al.,
*Sokrovisshcha russkogo naro-
dnogo iskusstva: rez'ba i
rospis' po derevu* (Moscow,
1966), pp. 130–31.

8. Hilton, *Russian Folk Art*,
pp. 38–40.

the side (fig. 2). In the register below we see the sailor driving a sleigh, and at the top a couple drinks tea from an enormous samovar: all the scenes are episodes of a leave on shore. It's tempting to see it as an extended self-portrait that shows the sailor's pride in his ship and his eagerness to reach home.

Among the region's painter dynasties, besides the Iarygins, we know the Misharins, Tretiakovs, Amosovs, and many others. Researchers on expeditions in the 1950s got to know the last generation of traditional painters and recorded what they had to tell about their training, methods of working, and even about the local market economy. One painter from a tiny village in the forest near Borok, Pelageia Amosova, was the daughter of an Old Believer who painted icons and manuscripts as well as domestic objects. She and her brothers all learned traditional techniques: preparing the board with gesso, much like an icon, inscribing major compositional elements with a stylus, painting in the colors, and applying gold leaf. They all set up shop in three or four small villages around the area. Like other peasant artists, they painted only in the fall and winter, and usually finished about fifty distaffs each year. Their work was "praised far and wide," Amosova said, adding that customers came more than a day's journey to buy distaffs from her and her brothers.[7]

Woodworking and textile arts reached impressive levels in the hands of master carvers and the creators of fine embroidery and lace. Every household, however, possessed basic skills in carpentry as well as in spinning, weaving, and sewing. Popular prints called *lubki* and carved toys show women using distaffs to spin linen or wool thread. The spinner sat on the horizontal base, placed a hank of rough linen on the projecting comb, and pulled the thread out in a rhythmic motion to wind it on a spindle. Women gathered to spin while they talked and sang, and sometimes they were joined by men during long winter evenings. Several distaffs depict these *posidelki*.[8] Distaffs were status symbols, so the decoration was most lavish on the side facing the room. The back was inscribed with names and dates or was painted fairly simply, with a space left in the center for a small mirror.

The implements used to make textiles show strong visual affinities to the textiles themselves, especially in the case of carved geometrical patterns and the repeated, stylized shapes in weaving and embroidery. Traditional patterns decorated the long towels that were hung over windows and icons, the bed linens, and the garments women prepared for their dowry chests. In the North, as in most of Russia, the basic

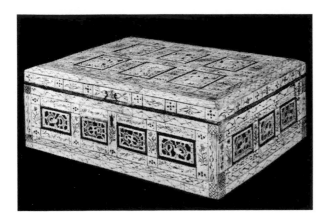

Figure 3
Box. Kholmogory.
Mid-18th century.
Walrus ivory, wood,
silk, mica. Hillwood
Museum and
Gardens, Washington,
D.C.

garment was called a *rubakha,* a knee- or ankle-length linen shift or shirt with appliquéd or embroidered borders. It was sometimes worn alone, but it was usually covered by a *sarafan,* a jumper-like dress cut on the bias to hang straight from the shoulders and decorated with embroidery, braided trim, buttons, and lace. Such details articulate the expanse of fabric and highlight the most important parts of the body—the hem, neckline, and shoulders—just as "carved lace" emphasizes the important structural elements of a house. Embroidery, like architectural carving, incorporated both allover pattern and symbolic motifs, stylized human figures, and mythical creatures.

Other forms of folk art required materials and tools not available in every household, and they were the basis of thriving markets in every region. In the far North, near Kholmogory on the White Sea, endless supplies of walrus tusk, whalebone, and even mammoth bone gave artists material for finely carved and inlaid chests (fig. 3) and other objects made not for local use but for wealthy buyers in cities and towns. Sent down the Northern Dvina River to trading centers, ivory carvings suggested ideas to artists who worked in their own local materials, using sharp knives to incise pliable layers of birch bark to decorate boxes to hold playing cards, game counters, or snuff.[9] Small boxes from the early nineteenth century feature a plump cupid and a popular fable, probably from an illustrated book. The town of Velikii Ustiug became a major center for the carving and distribution of birch-bark objects, and views of the city were often inscribed on the sides or lids of boxes (fig. 4), perhaps in imitation of city vistas engraved on silver and niello objects (such as those discussed by Anne Odom). These works were made in the same region and roughly the same period, but they were intended for different clienteles.

One medium especially important in the spread of images was the engraving. Books had been printed in Russia since the sixteenth century, and illustrated broadsheets, called *lubki,* probably originated as a means to make religious images available cheaply to everyone. Other kinds of information were published this way, in sometimes sensational newspaper-like stories. (One *lubok* depicting a whale caught in the White Sea describes a peculiarly Northern event.) Old Believer communities produced their own *lubki,* sometimes in ink and watercolor rather than prints, and many

9. Information on bone and birch-bark work is based on Irina Ukhanova, *Rez'ba po kosti vRossii XVIII–XIX vekov* (Leningrad, 1981), and Svetlana Zhizhina, "Severnaia reznaia beresta XVIII–XX vekov," dissertation, Institute of Art History, Moscow, 1976. See Hilton, *Russian Folk Art,* pp. 99–104.

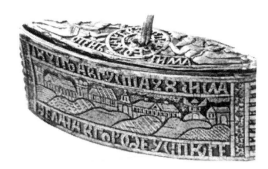

Figure 4
Snuffbox with a scene
of Velikii Ustiug.
Stepan Bochkarev.
Vologda Province,
Kadiakov village.
Early 19th century.
Birch bark. State
Historical Museum.

10. *Kultura Staroverov Vyga*
includes a genealogical table
superimposed on a monastic
compound and several plans
of Old Believer villages in
Olonets Province.

11. Robert Sears, *An
Illustrated Description of the
Russian Empire* (New York,
1855), p. 557.

12. The *podgolovok*, a chest
for valuables designed to be
kept under the pillow, was
made for Nikita Potapov in
1688; it is in the State
Historical Museum. See
Hilton, *Russian Folk Art*,
pp. 174–77.

of their manuscripts depict Northern settlements.[10]

Toys make up a special category that goes beyond the range of any single medium, region, or time period. An American visitor wrote in the 1850s, "The Russians have a peculiar talent for making figures and toys out of the most worthless materials in the world: straw, shavings, ice, dough, they turn all to account."[11] In the northern forests, they made *leshi,* or "woodfolk" out of pinecones and moss. A horse and sleigh made out of a few scraps of firewood was found in one of the farmhouses on Kizhi Island in Lake Onega.

At this point, I'd like to mention a few motifs that were especially popular in the North. We've already seen quite an array of animals, including horses, birds, and lions. Sometimes they are not just animals but distinct personalities: a lion on a cupboard from Vologda Province sports a prominent mustache that was very likely meant to resemble Peter the Great. In other cases, heraldic animals are symbols of fairly complex concepts. The lion and unicorn, a combination derived from Western heraldry (and used as the coat of arms of the first Moscow printing house) are depicted on distaffs by Iarygin and other Permogore painters. They are poised above the roof of a house, as if to protect the inhabitants. This combination is also found on chests and trunks made in Velikii Ustiug. One of the best examples is inside the lid of a chest for valuables made for a local merchant in 1688. The heraldic beasts prance around the trunk of a flowering tree, which symbolizes the Tree of Life, with its roots in the lower world and its branches in the sky. We can also see a more concrete, even practical purpose in the men standing to the sides: they are human guards who accompany the mythic protectors watching over the treasure.[12]

The presence of both realistic and symbolic elements throughout the peasant house, from the ridgepole of the roof, carved in the shape of a horse or a duck, to dishes and other household objects, is a constant reminder of half-forgotten beliefs about the forces of nature. In peasant culture, pagan nature spirits were never completely abandoned, even in the Christian era. The phenomenon known as dual faith, *dvoeverie,* was widespread. When peasants prayed to St. George, slayer of the dragon and protector of the land and agriculture, or to St. Nicholas, bringer of gifts, they

used an intimate, familiar vocabulary, as if addressing local divinities.[13] Images of these saints on Northern icons display lively ornaments characteristic of folk carving and painting. Other icons show special attention to the natural surroundings of the region: an unusual depiction of Adam and Eve from Kizhi abounds in vegetation, and a late work depicting John the Baptist (Stroganov school) places the figure in a forest. In many communities, the same artists who made household articles for villagers also worked on the decoration of churches. I stress the integration of pagan and Christian elements here because it is an aspect of Northern folk culture that most interested visitors to this region in the late nineteenth and early twentieth centuries.

While folk art preserved traditions, it also accommodated observations of real life. Depictions of social events became more frequent and elaborate as contacts between peasants and town dwellers increased. Folk art was always affected by the interactions among village, market, town, and monastery, and by direct contact between Northern peasant artists and their counterparts in major art centers. For instance, as early as the seventeenth century, master carvers of mammoth and walrus tusk in Kholmogory were invited to Moscow to fulfill commissions for the court. In the eighteenth and nineteenth centuries many spent several years working in St. Petersburg, where they became familiar with symbols and emblems of Western art as well as the prevailing classical forms, before they returned to their homes. (It's not surprising that one of Russia's great sculptors, Fedot Shubin, came from Kholmogory.) The adaptation and accretion of motifs continued into the twentieth century, when ivory carvers depicted civil war scenes and even icebreakers surrounded by Nenets sleds. The question of authenticity in the face of multiple exposure to new influences and professional training is still open to discussion. The issue of authenticity, and the related concept of immediacy (as opposed to conventionalized responses), also relates to the second topic of this paper: the perspectives and creations of outsiders, professional artists who traveled to the northern regions in search of inspiration.

Artists' Responses to the North: Landscape

The visions of the North that we find in late nineteenth- and twentieth-century Russian art are extremely varied, but in the most general terms we could say that they emphasize the special qualities of nature or aspects of native folk cultures, and sometimes both.

Ivan Shishkin's name is synonymous with the vast stretches of Russian forest, as Abbott Gleason's essay explains. At the beginning of his career, Shishkin traveled to the remote island monastery of Valaam in Lake Ladoga, as did many painters in the

13. Alison Hilton, "Piety and Pragmatism: Orthodox Saints and Slavic Nature Gods in Russian Folk Art," in William C. Brumfield and Milos Velimirovic, eds., *Christianity and the Arts in Russia* (Cambridge: Cambridge University Press, 1991), pp. 55–72.

late 1850s and 1860s. Shishkin made numerous drawings and oil sketches of trees and rocks, emphasizing their windswept asymmetry. Finished paintings, such as *View of Valaam Island* (1858, Museum of Russian Art, Kiev), and lithographs such as *Tangled Thicket (View of Valaam Island)* (1860) juxtapose fallen branches and crumbled, moss-grown rocks with fresh shoots of greenery, in keeping with the traditional romantic theme of the cycle of life. Much of Shishkin's mature work was done in Karelia north of St. Petersburg, in Vologda Province to the east, and Finland to the northwest, and he was best known for the immense size and ultra-realist detail of his major pieces. A late painting of a snow-crusted pine overlooking the Gulf of Finland, called *In the Wilds of the North* (1891, Museum of Russian Art, Kiev), and a related drawing conceived for an anniversary publication of Lermontov's works reveal the persistent romantic streak in this landscapist.

Arkhip Kuindzhi also worked on Valaam and around the shores of Lake Ladoga about a decade later. An early landscape, *Lake Ladoga* (1870, Russian Museum, St. Petersburg), records his impression of towering clouds above crystal clear water. His late works are remarkable: in *Patch of Moonlight in a Forest* (1898–1908, Russian Museum, St. Petersburg), tonality is everything. Natural forms become decorative almost to the point of abstraction. Other artists, such as Apollinarii Vasnetsov and Vasilii Surikov, who were not exclusively landscapists, created memorable visions of the Northern regions, including the Urals and Siberia.

Most of these artists were involved with the art colony at Abramtsevo, the estate of Savva and Elizaveta Mamontov, which became the center of a Russian art revival from the 1870s to the mid-1890s. The countryside around Abramtsevo was the setting for such major works as Viktor Vasnetsov's *Bogatyri* (1881–98, Tretiakov Gallery, Moscow) and Mikhail Nesterov's *Vision of the Boy Bartholomew* (1889–90, Tretiakov Gallery, Moscow) and other works in his series of paintings on the life of St. Sergei of Radonezh. Several members of the group, including Nesterov, Levitan, Korovin, and Serov, went further afield, seeking peculiarly Russian qualities in their far northern landscapes. Nesterov, a deeply religious person, devoted much of his time to monumental church paintings in Kiev and Sergiev Posad, but he also traveled in the North, partly in order to find the isolation and peace that were so important in forming the contemplative spirit of Russian monastics. Two works—*Winter in the Skete* (1904, Nesterov Art Museum, Ufa) and *The Calm* (1903, Tretiakov Gallery, Moscow), which depicts the silent monks of Solovetskii Monastery (fig. 5)—exemplify the combination of asceticism and solace through nature, with their restrained coloration and simplified compositions juxtaposing small, self-contained figures silhouetted against the

Figure 5
Mikhail Nesterov (1862–1942). *The Calm*. 1903. Oil on canvas. Tretiakov Gallery, Moscow.

14. Alla Rusakova, *Mikhail Nesterov* (Leningrad: Aurora, 1990), pp. 14–15, citing Nesterov's letter to A. Benua, 27 June 1896, in Alla Rusakova, ed., *M.V. Nesterov: iz pisem* (Leningrad: Iskusstvo, 1968), p. 111. Nesterov refers to P.I. Melnikov (pseud. Andrei Pecherskii), *V lesakh* (St. Petersburg, 1881).

15. Nesterov, letter to A. Turygin, 30 June 1896, in *Nesterov: iz pisem*, pp. 111–12. See Rusakova, *Mikhail Nesterov*, p. 14.

16. The term *nastroenie*, probably derived from the German *Stimmung*, appears in contemporary criticism, for instance, in *Artist: zhurnal iziashchnykh iskusstv i literatury*, Moscow, no. 35 (March 1894), pp. 140–41, where Levitan's works are characterized as landscapes of "mood," using the analogy to music. Levitan's subjects and styles are examined in V.S. Manin, "Zametki o tvorchestve Levitana," *Iskusstvo* 8 (1985), pp. 65–68; A.A. Fedorov-Davydov, *Isaak Il'ich Levitan. Zhizn' i tvorchestvo 1860–1900* (Moscow: Iskusstvo, 1976); and Vladimir Petrov, *Isaak Il'ich Levitan* (St. Petersburg: Khudozhnik Rossii, 1992).

broad, horizontal planes of the landscape. Inspired by the novels of mid-nineteenth-century writer Melnikov-Pecherskii about Old Believer settlements on the far banks of the Volga, Nesterov projected a "novel in paint" in which he described the lives of women who dedicate themselves to religious expression or simply live in the strange isolation of these communities.[14] *The Taking of the Veil* (1897–98, Russian Museum, St. Petersburg), though painted in Kiev, was one of this series, and it was the most evocative of what Nesterov wanted to convey. He wrote: "A connection between the landscape and the figure . . . a single thought in one and the other help to create a unity of mood."[15]

Isaak Levitan, best known for his portrayal of the expansive vistas and subtle effects of light along the Volga, also traveled to the northern coast, where he painted remains of an old fort against opalescent waves and clouds. The term "landscape of mood" is often used with Levitan's work.[16] Though paintings such as *Quiet Abode* (1890, Tretiakov Gallery, Moscow) contain Russian churches and bell towers, they are less concerned than Nesterov's with communicating a Russian spiritual feeling. They instead offer a remarkable intensity of vision, as if they were painted with "pathos," in Anton Chekhov's words.[17] Some dark, almost monochrome landscapes reflect a deeply melancholic strain in the artist's make-up. This mood, and indeed a preoccupation with the fleetingness of life, were typical of contemporary symbolist art and literature in Russia and other countries. Levitan loved nature too much, he once said, for melancholia, and the concreteness of his vision kept his work from becoming vague or mystical.

17. Anton Chekhov, letter to A. Suvorin, 19 January 1895, in A. Fedorov-Davydov, ed., *I.I. Levitan: Pis'ma Dokumenty Vospominaniia* (Moscow: Iskusstvo, 1956), p. 134.

18. Konstantin Korovin, note in a sketchbook used in 1891 (Tretiakov Gallery), in N. Moleva, ed., *Konstantin Korovin, zhizn' i tvorchestvo* (Moscow: Akademiia Khudozhestv, 1963), p. 213.

19. The idea of the "lyrical" landscape was presented by Korovin's fellow artist Nikolai Dosekin in an exhibition review in *Artist* 37 (May 1894), pp. 143–44. For subjective qualities in Korovin's style that distinguished Russian impressionism, see Alison Hilton, "The Impressionist Vision in Russia and Eastern Europe," in Norma Broude, ed., *World Impressionism: The International Movement 1860–1920* (New York: Harry N. Abrams, 1990), pp. 370–406, esp. 387–92.

20. Information on Korovin and Serov's northern journey is based on Korovin's memoirs. See I.S. Zilbershtein and V.A. Samkov, eds., *Konstantin Korovin Vspominaet* (Moscow: Izabrazitel'noe iskusstvo, 1990), pp. 279–97. Several of their works from this trip are in the Russian Museum and the Tretiakov Gallery; some sketches are in private collections and many are lost.

Valentin Serov and Konstantin Korovin, close friends from their early days at Abramtsevo, were interested in landscape as well as in portraiture, and they sought to capture the qualities of an individual's appearance or of a fragment of nature with apparent spontaneity. Korovin was attracted to French Impressionism and painted café and boulevard scenes in Paris. However, he wanted his Russian works to be more than fleeting glimpses of corners of nature. He wrote in a sketchbook: "Landscape should not be painted without a goal, for the sake of beauty alone, but rather so that through the landscape something significant may be reached, something close to the spirit of nature. . . . It should resonate to a deep, sincere feeling. This is hard to express in words, it is so close to music."[18] Korovin's paintings of northern Russia, such as *Winter* (1894, Tretiakov Gallery, Moscow), emphasize effect rather than description, a muted harmony of silvery grays that his friends recognized as poetic or lyrical.[19] At the same time, Serov, always more attuned to the activities of people in various settings, subordinated narrative detail to a similar overall effect, especially in rural scenes painted at a friend's estate in Tver Province or near the Gulf of Finland north of St. Petersburg. These two artists concentrated intently on the task of expressing the character of the Russian North when they spent several months together in 1894, traveling and painting over a good deal of territory in the North, on a commission from Savva Mamontov.

Mamontov wanted to generate publicity for his planned extension of the northern railroad line to Vologda, Arkhangelsk, and Murmansk, with a connection by ship to Norway. He planned to hang paintings of northern scenes in stations from Moscow to Iaroslavl and beyond, and to publish reproductions in an album. Korovin and Serov were enthusiastic about the project. They spent the summer and part of the autumn traveling as far as the Norwegian port of Hammerfest, and then from Vologda up the Sukhona and Northern Dvina Rivers on the *Lomonosov,* the best steamboat in the Arkhangelsk-Murmansk River fleet, to the Arctic Ocean and the island of Novaia Zemlia.[20] They made watercolor and oil sketches of northern villages, with some including peasants and livestock or fishermen and boats on the coast of the White Sea. Serov painted several studies of Arkhangelsk, the Murman coast, villages in Norway, and a strikingly barren seascape seen in *The Northern Dvina* (1894, Art Museum, Ivanovo). Korovin painted the wharfs at Arkhangelsk and other northern Russian ports. His most finished work on this theme, *Hammerfest. Northern Lights* (1895, Tretiakov Gallery, Moscow), shows the harbor strangely illuminated by the Aurora Borealis.

Figure 6
Valentin Serov (1865-1911). *In the Tundra. Reindeer Ride.* 1896. Gouache, India ink, graphite. Tretiakov Gallery, Moscow.

Figure 7 (right)
Konstantin Korovin (1861–1939). *Northern Lights.* 1896. Oil on canvas or masonite. Tretiakov Gallery, Moscow.

Both artists were struck by the way the sky dominated the enormous flat expanses of snow-covered tundra, punctuated by the silhouette-like shapes of reindeer and sleighs, as we see in Serov's gouache *In the Tundra. Reindeer Ride* (fig. 6) and in Korovin's more stylized murals, including *Northern Lights* (fig. 7), painted to decorate a special "Northern Pavilion" at the 1896 Nizhnii Novgorod trade fair. Korovin designed the building itself like a large barn with a steep roof covered with glass and decorated with carved beams. This was a prelude to the more elaborate "Russian Village" he designed for the Paris World's Fair in 1900. The paintings show traditional activities, such as hunting, juxtaposed felicitously with signs of development and industrial potential, which the railway would make accessible to the rest of Russia. Photographs of the exhibition show Korovin's panels among a lavish display of furs. Although the project was a commercial one intended to promote the extension of the railroad to the north and into the Urals, the experience for the artists had profound and long-lasting effects.

Folklife and the Northern Coloration

Abramtsevo was not only a center of painting but also an incubator for experimentation in theatrical design and the chief locus of the arts and crafts revival. Serov and Korovin belonged to the cohort within the Mamontov group who were interested in reality and natural effects rather than fantasy and folk art, but even they were affected by the group's prevailing interests. Korovin made posters for a revival of the fairy-tale opera *Snegurochka* (originally designed by Vasnetsov), and his early painting *Northern Idyll* (1886, Russian Museum) shows women dressed in Northern costume listening to a boy playing panpipes, much like a scene in the opera. Another artist who

Figure 8
Ivan Bilibin
(1876–1942). *Folk Art
of the Russian North.*
Title page of *Mir
iskusstva* (World of
Art). 1904.

21. Elena Polenova, letter to
P. Antipova, 16 April 1881,
in E. Sakharova, ed., *V.D.
Polenov - E.D. Polenova:
Khronika sem'i khudozhnikov*
(Moscow: Iskusstvo, 1964),
p. 362.

22. Ivan Bilibin, "Narodnoe
tvorchestvo russkago severa,"
Mir iskusstva 12, no. 6
(1904), p. 303.

worked at Abramtsevo, Vasilii Surikov, made studies of people and settings in his Siberian homeland, such as a watercolor of an icon corner in a peasant house (1883, Tretiakov Gallery, Moscow), in preparation for his large historical paintings.

The carpentry and embroidery workshops organized by Elena Polenova and Elizaveta Mamontova based most of their work on objects found in central Russia (the Moscow, Vladimir, Ivanovo, and Iaroslavl regions). The Polenovs frequently visited their family home Imochentsi on Lake Onega, and Polenova combined regional styles rather freely in her designs for furniture, embroideries, and in her folk-tale illustrations. The subjects and motifs of her illustrations were, she said, "taken directly from the soil," based on visits to isolated villages and monasteries. By training local peasants in traditional crafts, Polenova hoped, as she said, to "capture the still living creative spirit of the people, and give it the opportunity to develop."[21] The folk coloration and "creative spirit" that permeated Abramtsevo—seen in a ceramic bench with a *sirin* by Mikhail Vrubel and a twelve-foot-high embroidered panel based on the fairy tale of *The Firebird* designed by Polenova—typified the Slavic revival and greatly stimulated the imaginations of artists in the next generation.

Other artists turned to the North for their own reasons. Abram Arkhipov, a friend of Polenova, made numerous trips to the White Sea coast, where he painted scenes of fishing villages in subdued silvery tones, and peasant women whose brilliantly colored dresses seem to radiate in the northern light. Arkhipov's *Guests* (1914, Tretiakov Gallery, Moscow) shows a gathering much like the *posidelki* depicted on distaffs. Ivan Bilibin, who was fascinated by Russian legends and fairy tales and completed several illustrated books, traveled widely in the North. He made expeditions to Vologda, Arkhangelsk, Olonets, and Tver Provinces to collect samples of folk art, especially embroidery, and to photograph wooden architecture for the ethnographic department of the Russian Museum (which later became part of the State Ethnographical Museum in St. Petersburg). Bilibin produced a set of postcards illustrating regional costumes, and in 1904 he published articles on "Folk Art of the Russian North" (fig. 8) and "Remnants of Art in the Russian Village" for the *World of Art* journal, *Mir iskusstva*. Bilibin believed that folk art was dying and that only in the most remote places, such as these northern regions, did "its last feeble sparks still smolder."[22] Perhaps better than the Abramtsevo group, he knew that

historical and economic changes would not let the folk arts remain pure and unchanged, and he hoped to preserve the environments in which traditional arts might continue to develop as living phenomena.

Interpretation of the Northern Spiritual Legacy

Nikolai Rerikh and Vasilii Kandinskii both felt the pull of the North, and they tried to express the coloration and rhythms of folk life as well as the ageless spiritual legacy of the region.[23] Both men took part in ethnographic expeditions to the North before becoming artists. When Kandinskii first reached the remote settlements of the Zyrians (or Komi) beyond the Northern Dvina River, he felt that he had encountered a new world. "In these extraordinary huts I first encountered the miracle that became subsequently one of the elements of my work. It was here that I learnt not to look at the picture from the side, but to revolve in the picture myself, to live in it. I can remember vividly stopping on the threshold of this amazing spectacle. The table, the benches, the stove so imperious and so huge, the closets, the sideboards—everything had been painted with multi-colored and bold ornaments."[24] A decade later, Kandinskii painted shimmering fairy-tale subjects, and from these works he went on to develop insights into the powers of pure color and abstract form.

Rerikh's identification with ancient Russia came from his Scandinavian family background and early contacts with historians and archeologists. As a boy he even learned how to excavate burial sites near the family estate southwest of St. Petersburg.[25] He dedicated much of his art to Russian subjects, and he planned a series of works depicting the time when Slavic tribes and Varangian traders from Scandinavia occupied and competed for the Russian plains and forests. He traced part of the Varangian river route by steamboat in 1899. His first major work, *The Messenger. Tribe has Risen against Tribe* (1897, Tretiakov Gallery, Moscow), emphasized a brooding atmosphere. In 1900 Rerikh went to Paris for a year, admired the work of Gauguin, Degas, and Puvis de Chavannes, and began to work with flatly applied, bright colors. Painted right after his return, *Guests from Overseas* (1901, Tretiakov Gallery, Moscow) shows a Varangian ship in brilliant bands of color against an intense blue sea.

Rerikh's fascination with ancient Northern peoples is reflected in works such as *The North* (1902, Kiev Museum of Russian Art), *Triumph* from the series *Vikings* (fig. 9), *The Stone Age* (1910, private collection, United States), published in the journal *Apollon*, and most dramatically in *Battle in the Heavens* (1912, Russian Museum, St. Petersburg).

23. I discussed Rerikh and Kandinskii in the context of archaic Russian subjects in the paper "Turn of the Century, Return of the Senses: Decadence, Archaism, and Primitivism in Russia," delivered at the annual meeting of the College Art Association, February 1997.

24. V. Kandinskii, "Tekst khudozhnika" (Moscow, 1918), translated in John Bowlt and Rose-Carol Washton Long, *The Life of Vasilii Kandinsky in Russian Art* (Newtonville, Mass.: Oriental Research Partners, 1980), p. 2.

25. For Rerikh's background and Russian subjects, see E.I. Poliakova, *Nikolai Rerikh* (Moscow: Iskusstvo, 1973), pp. 3–205, and Jacqueline Decter, *Nicholas Roerich: The Life and Art of a Russian Master* (Rochester, Vt.: Park Street Press, 1989), pp. 9–95.

Figure 9
Nikolai Rerikh
(1874–1947). *Triumph*
from the series
Vikings. 1909. Oil on
canvas. Published in
Apollon 1 (1909).

Rerikh became well known in the West as the designer for Diaghilev's production of Borodin's opera *Prince Igor* (1908), evoking the vastness of the steppe and the splendid wildness of Asia. This was a prelude to the more radical—and distinctly Northern—ballet *The Rite of Spring,* a collaboration with Stravinskii and Nijinskii.[26] The ballet recreates a primitive ritual. Tribe members gather near a sacred hill and perform acts to bring about the return of spring. The maidens dance in a circle until one of them is chosen by the sun-deity Iarilo. She becomes possessed and dances herself to death to renew the earth. Rerikh's sets and curtains, with their cool blues, greens, and yellows, evoked a northern landscape returning to life after winter. The white and red costumes were distinctly Northern, rich with embroidery. Nijinskii studied Rerikh's paintings as he worked out the postures and steps for the dancers. At the Paris première in 1913, the audience went wild, but then grew quiet, attentive and shocked, as they witnessed the chosen one's final frenzy.

Like Rerikh, Kandinskii valued his Russian and Siberian ancestry and expressed enjoyment in the colorful atmosphere of Old Russia in works such as *Song of the Volga* (1906, Musée National d'Art Moderne, Centre Georges Pompidou, Paris). As a law student at Moscow University, he became interested in peasant law and ethnography. He published articles on the laws and beliefs of the Zyrian people, based on his six-week ethnographic expedition to northern Vologda Province in May and June of 1889. His boat trip up the Northern Dvina and Sukhona Rivers to remote Ust Sysolsk impressed him with the serene depth of nature and the colorful houses, clothing, and folk rituals of the Zyrians. He was alert for signs of the coexistence of pagan and Christian beliefs, the phenomenon known as *dvoeverie* (dual belief) common

26. On Rerikh's theatrical designs, see Poliakova, *Rerikh,* pp. 159–74, and Decter, *Roerich,* pp. 71–94.

throughout Russian folk culture. Peg Weiss explored this material in her book *Kandinsky and Old Russia*, but it is impossible to overemphasize how significant the Northern identity was for this ground-breaking artist's development of abstraction.[27]

Kandinskii's early works contain nostalgic images from Russian and Nordic folklore and descriptive scenes of northern Russia. He painted the more ambitious *Song of the Volga* during his 1906 trip to Paris. The work calls for comparison with Rerikh's *Guests from Overseas* in that it shows not only a shared interest in the Russian North but also a perception sharpened by distance. Unlike Rerikh, Kandinskii introduced Orthodox Christian symbols, such as the icon on the mast of the central boat and the bell tower visible in the background. Kandinskii may have wanted to emphasize religious elements as a way of distinguishing Russia from Europe, or traditional cultures from the materialist present. *Motley Life* (1907, Staedtische Galerie im Lenbachhaus, Munich) made his fullest statement of the pagan-Christian duality, incorporating observations from his ethnographic expedition, his knowledge of Zyrian religion, and a rich store of Russian folklore. The composition is based on polarities—the bearded pilgrim or sorcerer and the mother with child at the center; the priests on the left, lovers on the right; warrior, archer, and battle at the center; and the spired kremlin above them—and it pulls all these dualities together into a variegated but unified life.

The theme evolved in radically altered form in the sketch for *Composition II* (fig. 10). The crowded, fluid painting mingles sketchy human shapes with trees and mountains, forms that suggest both Christian saints and Zyrian nature spirits. This painting and related works reflect Kandinskii's understanding of *dvoeverie* as a complex interweaving of different worlds. The overlapping of pagan and Christian elements expands in *All Saints I* (1911, Staedtische Galerie im Lenbachhaus, Munich), framed by a trumpeting apocalyptic angel and a large sunflower, a symbol of the ancient Slavic sky-god Perun. St. George bears a shield emblazoned with the sunburst symbol of the pagan Iarilo, a conflation found in Russian icons. *All Saints II* (1911, Staedtische Galerie im Lenbachhaus, Munich) includes St. Elijah in his fiery chariot, associated with the sky-god Perun by Russian peasants. Another figure, a rider on a white horse, seems to combine traits of St. George, the Slavic sun-deity Iarilo, and the Zyrian World-Watching-Man.[28] The constant shifting of identities was true to the culture these works evoked.

The publication of the *Blaue Reiter Almanac* in 1912 was a culminating point for Kandinskii, just as *The Rite of Spring* was for Rerikh. Both works celebrated healing, renewal, and restoring harmony through an understanding of "primitive" artistic

27. Peg Weiss, *Kandinsky and Old Russia: The Artist as Ethnographer and Shaman* (New Haven: Yale University Press, 1995). The author began investigating this material in 1985 and presented it in several lectures and articles, including "Kandinsky and 'Old Russia': An Ethnographic Exploration," in Gabriel Weisberg and Laurinda Dixon, eds., *The Documented Image: Visions in Art History* [Festschrift for Elizabeth G. Holt], (Syracuse: Syracuse University Press, 1987), pp. 187 222 I am profoundly grateful that Peg Weiss shared her insights with me over the years.

28. Weiss, *Kandinsky and Old Russia*, pp. 56–63, identifies and discusses many other components of these and related works.

Figure 10
Vasilii Kandinskii
(1866–1944). *Sketch
for Composition II.*
1909–10. Oil on
canvas. The Solomon
Guggenheim
Foundation, New
York.
Photograph by Robert E.
Mates.

expression, specifically that of the Russian North. Kandinskii and his colleague Franz
Marc wrote about the need for a new element of the "spiritual in art" to restore bal-
ance in the world.[29] His sketches for the cover, derived from the St. George icon,
reinforced the theme. St. George slaying the dragon symbolized triumph over winter
and the return of spring, and on another level, spiritual salvation. The Blue Rider as
both intercessor and restorer of harmony was the model for Kandinskii's sense of him-
self as an artist, a visionary who traveled between different worlds.

Rerikh's and Kandinskii's experiences were strikingly parallel. During times of dis-
ruption, World War I, the Russian Revolution, and emigration, they drew upon sym-
bols of their complex Russian heritage, and they recalled their northern explorations
in evocative images. Rerikh revived some of his motifs from prehistoric and early
medieval Russia and later combined them with scenes from his travels in the
Himalayas, Mongolia, and Altai, which Rerikh knew was the legendary homeland of
Finnish tribes. In contrast to Rerikh's figurative work, Kandinskii's recreations of
Russian motifs were increasingly abstract and geometric, such as the horse and rider
discernible in *In the Black Square* (1923, Solomon R. Guggenheim Museum, New
York). One late work, *Launisch/Peevish* (1930, Museum Boymans-van Beuningen,
Rotterdam), conveys the sensations of a northern journey especially vividly. The dom-
inant shape is like a barge with a single mast and a tail-like rudder; figures and shel-

29. See Bowlt and Long, edi-
tion of Kandinskii's *On the
Spiritual in Art* (1911), in
*The Life of Kandinsky in
Russian Art*, pp. 63–112; *The
Blaue Reiter Almanac,* ed. by
Klaus Lankheit (New York:
Viking, 1974).

ters occupy the deck; fish-like and bird-like forms swim and fly around the boat; and faintly outlined, like a mirage, spired buildings glide by in the distance.[30] Even in late works, Kandinskii seems to reflect upon the metaphoric journey of the artist between vastly differing worlds.

In a sense, Kandinskii's work was the culmination of a theme that we have already identified in the art of the Russian North. Korovin and Serov had been strongly impressed by the continual movement of the Lapps and their reindeer herds and by the extent and duration of their own river journeys. For local artists, too—the folk painters of the Northern Dvina and Mezen River areas—the journey by boat or sleigh was one of the most popular and most meaningful in their repertoire of motifs. Recalling their various responses to nature and regional culture, I would suggest that a unifying perception might be this sense of space. For those who lived in the North and for those who went north on either practical or spiritual quests, spaciousness also imparted a feeling for the very slow pace of change, of timelessness.

Soviet Art and the North

Appreciation for the unique qualities of northern topography and life did not end after the Revolution, although we tend to think that one of the goals of Soviet cultural policies was to assert the unification of the many racial and ethnic components of the Soviet people. As a coda to my essay, I will look very briefly at some of the ways Soviet artists presented the North.[31] Landscapes of northern regions—ranging from Arkadii Rylov's emphatic *Into the Blue Distance* (1918, Tretiakov Gallery, Moscow) to Vasilii Meshkov's pensive *Golden Autumn in Karelia* (1952, Tretiakov Gallery, Moscow)—carry on the tradition of Shishkin, Levitan, and Korovin, but many landscapes and genre scenes convey obvious patriotic messages. A scene of voting in a northern district, Aleksandr Volkov's *Election Day for the Supreme Soviet* (1949, Russian Museum, St. Petersburg) celebrates local color and ethnic types while it emphasizes the benefits of the Soviet system. The northern setting was ideal for the major Soviet themes of heroic labor under harsh conditions and the impressive achievements in developing resources, such as oil and transport systems, across the huge territory. The most famous project was the White Sea Canal, depicted by Sergei Gerasimov in *Baltic-White Sea Canal* (1933, Tretiakov Gallery, Moscow), Aleksei Shovkuchenko in *A Steamboat Goes through the Lock* (1936, Tretiakov Gallery, Moscow), and Aleksandr Rodchenko, whose 1933 series of photographs documenting the construction were exhibited in Moscow and published in *Sovetskoe Foto* in 1935 (fig. 11).

30. Peg Weiss discussed this image and its component parts in her commentary for a session that we co-chaired, "The Northern Identity: Meetings of Mind, Myth and Metaphor in Nineteenth and Twentieth Century Art," at the annual meeting of the College Art Association, February 1990.

31. Among recent studies dealing with the subject are Mark Bassin, "'I Object to Rain that is Cheerless': Ideologies of Nature and the Discourse of Landscape Art in Stalinist Aesthetics," paper presented at the annual meeting of the American Society for the Advancement of Slavic Studies, September 1998, and Karen Kettering, "Severnyi polius: Imaging the Soviet Arctic in the 1930s," paper presented at the annual meeting of the College Art Association, February 1998.

Figure 11.
Aleksandr Rodchenko
(1891–1956). *The
Baltic-White Sea
Canal.* Published in
Sovetskoe foto, 1935.

A large proportion of Northern scenes were not overtly declamatory but rather suggested glimpses of typical life in the region, as in landscapes by Viacheslav Zagoniek, Valerii Semenov, and Nina Sergeeva. Dmitrii Sveshnikov's *White Nights* (1972, Ministry of Culture of the Russian Federation) offers something more. A young man and woman stand silhouetted against the pale sky of the Northern summer night, with the forms of reindeer visible in the background. It is a familiar love story, enlivened with the costumes of Lapland.

Beneath these upbeat impressions of the North lies a different reality. The White Sea Canal was built by Gulag prisoners. Although Rodchenko's photographs emphasize pride and unity of purpose—even recording the prisoners' band that accompanied work on a lock for the sake of observers—the workers who excavated the canal died at an appalling rate. A generation later, noted theater artist Petr Belov commented on this tragic result of Stalin's hubris in his small gouache painting *Belomorkanal* (1985, estate of the artist), showing a pack of this popular brand of cigarettes torn open to release masses of minuscule prisoners onto a featureless plain surrounded by barbed wire. Many writers and artists have described exile and prison in the North. The existence of the Gulag fundamentally changed the character of the region in memory and imagination. One veteran of the prisons still ponders the millions of victims in unmarked graves, whose bones are among "the principal fossil remains beneath the earth of my vast native land."[32] I remember my own shock of realization when a fellow passenger on a boat passing through canal locks told me that whenever she looked down into the water beneath us she saw bones. One of the most laconic and moving of the visual images produced in the past few years is Gennady Ustiugov's *Shadows Still Moving Around Prisons* (1989, private collection).

Soviet propaganda at one extreme and agonized protest on the other: both are part of the complex image of the Russian North. Between these polar oppositions, art of the past and the present day offers continual reflection on the demanding and compelling northern environment. Reminders of the Gulag will probably remain a part of

32. Lev Razgon, *True Stories* (Ann Arbor: Ardis, 1995), p. 1 (on eighteen years in northern labor camps and in exile in the North). See also Aleksandr I. Solzhenitsyn, *The Gulag Archipelago 1918–1956: An Experiment in Literary Investigation,* trans. Thomas P. Whitney (New York: Harper Row, 1974–79), and Eugenia Ginzburg, *Within the Whirlwind,* trans. Ian Boland (New York: Harcourt Brace Javonnovich, 1978), on her eighteen years in camps in far eastern Siberia.

the Northern vision for a long time to come. Juxtaposed with Ustiugov's profound isolation, however, are other images expressing a sense of belonging, such as a shimmering snowscape and a peace-filled interior of a tiny Northern church, painted by a young Northern artist in the early 1990s.[33] Here, the extremes of climate and topography are subsumed in a feeling of integration, echoing Mikhail Nesterov's perception of the "connection between the landscape and the figure . . . a unity of mood."[34]

33. N. Tretiakov, *Homeland of Belov* (1992) and *In a Forgotten Church* (1992), exhibited in Tver Exhibition Hall (present location unknown).

34. Nesterov, letter to A. Turygin, 30 June 1896, in *Nesterov: iz pisem,* pp. 111–12.

Index

Page numbers of illustrations appear in italics.